LOS ANGELES DODGERS

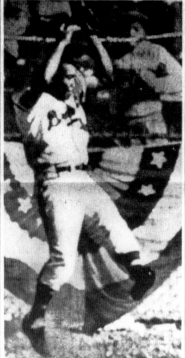

BANNER NEWS. On October 7, 1957, the Los Angeles City Council voted to bring the Brooklyn Dodgers National League baseball team to a new home in Los Angeles. The Dodgers moved to the West Coast after an unsuccessful 10-year campaign to build a new ballpark in New York. Southern California fans already were exposed to professional baseball, thanks to the Pacific Coast League's Hollywood Stars and Los Angeles Angels.

LOS ANGELES DODGERS

Mark Langill

ARCADIA

Published by Arcadia Publishing,
an imprint of Tempus Publishing, Inc.
Charleston SC, Chicago, Portsmouth NH,
San Francisco

Printed in Great Britain.

Library of Congress Catalog Card Number: 2003115365

For all general information contact Arcadia Publishing at:
Telephone 843-853-2070
Fax 843-853-0044
E-Mail sales@arcadiapublishing.com

For customer service and orders:
Toll-Free 1-888-313-2665

Visit us on the internet at http://www.arcadiapublishing.com

For my All-Star nephews, Mark and Michael Rayala

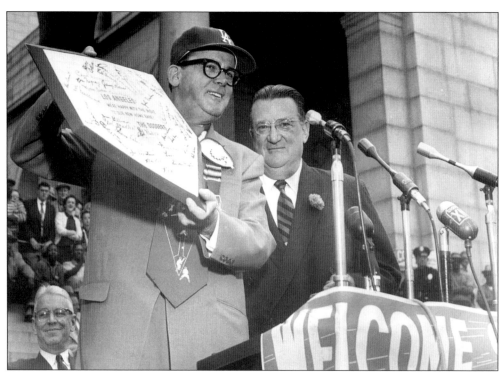

WELCOME TO LOS ANGELES. Mayor Norris Poulson receives a home plate signed by members of the new Los Angeles Dodgers during Opening Day ceremonies at City Hall of April 18, 1958. The gift from Dodger president Walter O'Malley carried the inscription, "LOS ANGELES: We're Happy With The Move To Our New Home Base! —THE DODGERS."

CONTENTS

Acknowledgments 6

Introduction 7

1. From Brooklyn to Los Angeles 9

2. The Coliseum Years 19

3. Dodger Stadium 41

4. The 1970s 59

5. The 1980s 77

6. The 1990s 95

7. 2000 and Beyond 113

ACKNOWLEDGMENTS

For this book, special thanks to my colleagues in the Dodger front office, including Communications Vice President Derrick Hall, External Affairs Vice President Tommy Hawkins, and the members of the publicity and broadcasting departments: Paul Gomez, Chris Gutierrez, Dave Tuttle, John Olguin, Josh Rawitch, Donna Carter, and Rachelle Smith.

Current Dodger photographers Jon SooHoo, Juan Ocampo, and Jill Weisleder chronicle the team on a daily basis, continuing the tradition of past Dodger photographers Frank Worth, L. Andrew Castle, Andrew Bernstein, Art Foxall, Mark Malone, Don Ploke, Darryl Norenberg, Mike Cronin, Richard Kee, Craig Molenhouse, and Alvin Chung. Special thanks to Baseball America photographer Larry Goren and MLB.com producer Ben Platt for their assistance with the latest technology in digital cameras and computers.

And thanks to the members of the Dodger Alumni Association, the former Brooklyn and Los Angeles players, coaches, and executives who keep history alive with their stories and memories of Dodger baseball.

INTRODUCTION

A young baseball fan is usually the product of their environment and this author is not an exception to this rule. Although six years as a beat reporter for the *Pasadena Star-News* and another decade behind the scenes in the Dodger front office has provided the necessary journalistic background for objectivity, one cannot forget childhood images.

In this case, could there have been anything more Norman Rockwell or admittedly corny than sitting in the Left Field Pavilion, armed with a transistor radio and blank scorecard, and anticipating what might happen over the next three or four hours. Imagine a mother baking under a hot sun, dutifully marking down play-by-play details on a paper cup while her son was deciding which item to purchase at the souvenir stand. Or a pesky little sister who couldn't understand Jimmy Wynn's importance to world events, yet who rode along in the car knowing there might be a hot dog or popcorn in her future. At least she knew never to change the television channel if Vin Scully was on the air, one of nature's basic laws.

A grandmother, a beautician by trade and definitely not a sports fan, in her working days once passed along from her customer a set of "Game Notes" from the press box at Dodger Stadium. Her husband was a local sportswriter and she heard of a youngster who liked baseball. Those discarded statistical sheets, containing the updated behind-the-scenes information printed on official team letterhead, are still tucked away somewhere 30 years later in a drawer for safekeeping.

If one becomes a baseball fan, there is a chance the sport creeps into the daily routine, even if just subconsciously wondering about the current score when going to bed early. And there is the danger of speculating to others brave enough to listen—whether the next day's result or predicting the entire season's outcome at the outset of spring training. Historians have it easier, though, because even a polished debating crew can't change the results of the seventh game of the 1962 World Series.

The marriage of the Dodgers and Los Angeles was an accidental pairing of sorts, yet somehow it blossomed into a relationship between a storied baseball franchise and already great metropolitan city. After seven decades in Brooklyn, the Dodgers moved to Southern California in 1958 and into a hotbed of baseball interest, thanks to the longtime Pacific Coast League

franchises Hollywood Stars and Los Angeles Angels. And along with the Dodgers came their relocated rivals, Willie Mays and the San Francisco Giants.

When San Francisco's Candlestick Park closed its doors in 1999, former Dodger Manager Tommy Lasorda strolled onto the field during special ceremonies. The expected boos were thunderous in volume and emotion. Lasorda, bombastic and boastful in the heat of battle in 20 years as the enemy skipper, egged on the crowd with a mere charitable wave and devilish grin as he walked from the outfield toward the visitor's dugout, both sides embracing the characters of an ongoing Dodger-Giants stage production that began in 1884.

More than 123 million fans have attended Dodger home games since their arrival to the West Coast in 1958. It's impossible to measure their level of interest, or their source of inspiration, but their reasons are as diverse as the backgrounds of the players on the field.

Somewhere, there is an argument brewing with a calculator-toting student of the game, ready to "prove" why Eric Gagne is a more effective closer than Oakland's Dennis Eckersley in his prime. Or why Duke Snider would have reached 500 career home runs if he played his entire career at Brooklyn's Ebbets Field. Such hypothesis is natural for the fan in the stands.

For those with a closer look at the industry, some of the most special moments occur in the most unexpected places. For example, Oldtimers Day participants don their uniform with pride and precision, fidgeting the last details like a nervous teenager primping for a first prom. Give an aging hero in his sixties or seventies a Dodger jersey to wear and suddenly in his heart he can still rope a double into the power alley.

Or consider the fresh-faced innocence of a Dodger rookie participating in his first Instructional League, whimsically asking his instructor, "Did you ever see Sandy Koufax pitch?" Statistics are readily available, but the stories from both players and fans become the treasured heirlooms.

Today's elementary school students might not know the complete roster of the current players, but the true-life tale of Brooklyn Dodger teammates Jackie Robinson and Pee Wee Reese during the 1947 season is part of their American history books, alongside George Washington and Abraham Lincoln.

The photos in this book range from Hall of Famers performing under average circumstances to journeymen who became Cooperstown material, if only for a day. Many images are being published for the first time, perhaps shedding new light or perspective on a moment already etched in one's mind.

Prior to the Dodgers' first home game at the Los Angeles Memorial Coliseum, starting pitcher Carl Erskine had trouble sleeping. The veteran of five World Series and author of two no-hitters didn't have any margin for error in this unique assignment. "I thought about that first pitch all night," he said. "I wanted the first pitch in Los Angeles to be a strike."

The following afternoon, the Giants' Jim Davenport climbed into the batter's box in front of a crowd of more than 78,000 and took Erskine's first pitch—a called strike. Life in Los Angeles would never be the same.

ONE

From Brooklyn to Los Angeles

Brooklyn made its debut in the National League a positive one in 1890 as the team, nicknamed the "Bridegrooms," won the championship with an 86-43 record. It was the first of 21 pennants the Dodgers would win during the next 100 years. The moniker "Bridegrooms" was attached to Manager William "Gunner" McGunnigle's 1890 ball club because seven of the players got married around the same time in 1888.

Baseball was not new to Brooklyn, which had fielded a team as early as 1849. Charles Byrne, president of the Brooklyn club that started the Interstate League and moved into the American Association, built Washington Park on the approximate site where George Washington's Continental Army had fought the battle of Long Island. The Dodgers of 1890 transferred to the National League from the American Association, where they had won the 1889 pennant.

The term "Trolley Dodgers" was attached to the Brooklyn ball club due to a complex maze of trolley cars that weaved its way through the borough of Brooklyn, and newspaper headline writers shortened the name to just "Dodgers." During the 1890s, other popular nicknames were Ward's Wonders, Foutz's Fillies, and Hanlon's Superbas.

The American League was formed in 1900 and three years later began playing its National League rivals in a "World Series." The first few decades of the 20th century featured colorful Dodger characters on the field, but their status as contenders was frustratingly sporadic and the team usually stepped aside in October to watch other New York teams, the Giants or Yankees, hoist a championship flag.

The fortunes of the franchise began to change in 1939 with the synergy of three men: team president Larry MacPhail, who convinced the owners to spend money to make the Dodgers a contender; Leo Durocher, the street-wise skipper who instilled a winning spirit; and broadcaster Red Barber, whose calm and soothing Southern voice gave the Brooklyn borough a summer soundtrack as major league teams increasingly began using radio to reach their fan base. Ebbets Field, the neighborhood ballpark built in 1913, became the site for baseball's first night game in 1938 and its first televised game in 1939.

MacPhail's departure during the 1942 season to enter World War II opened the door for another Hall of Fame innovator, Branch Rickey, the father of baseball's minor leagues system

who was willing to integrate the major leagues, if he could find the right player. Rickey in 1945 signed Jackie Robinson, a former multi-sport star at UCLA who briefly played professional football before entering the military. One of Rickey's scouts spotted Robinson playing for the Kansas City Monarchs in the Negro Leagues, and at age 27, Robinson spent the 1946 campaign at the Dodgers' Triple-A affiliate in Montreal. His Rookie of the Year campaign in 1947 was more than a successful baseball story and is considered by many as the most significant event in American sports history.

But Robinson also made the Dodgers winners on the field and Brooklyn appeared in six World Series during Robinson's Hall of Fame career from 1947 to 1956. The Dodgers won their first and only championship in 1955 with a thrilling seven-game classic against the New York Yankees, to whom they had lost in seven previous October meetings beginning in 1941.

When Walter O'Malley succeeded Rickey as Dodger president in 1950, success on the field continued as the roster of famous players enjoyed the prime of their respective careers. Those Dodgers included Duke Snider, Gil Hodges, Roy Campanella, Don Newcombe, Carl Furillo, Clem Labine, Carl Erskine, and team captain Pee Wee Reese.

But O'Malley was also a shrewd businessman who, beginning in 1946 as team counsel, lobbied New York officials for a new ballpark because the cozy Ebbets Field couldn't compare to the parking and seating capacities offered by newer facilities. In an era before an amateur draft and free agency, O'Malley monitored the success of a Braves franchise that transferred from Boston to Milwaukee in 1953, which resulted in increased attendance from 281,278 at Braves Field to a league-record 1.8 million at County Stadium.

O'Malley wanted to build a new ballpark, but his ideas clashed with New York Commissioner Robert Moses, an assistant to Mayor Robert Wagner, who was in the charge of public use of parks and highways. Meanwhile in Los Angeles, *Herald-Examiner* columnist Vincent X. Flaherty and City Supervisor Kenneth Hahn were among a handful of influential supporters who wanted to lure a major league franchise to the West Coast. The overnight success of the new Milwaukee franchise gave other struggling owners grand ideas, and the Giants' Horace Stoneham pondered a move from the Polo Grounds to Minneapolis. Los Angeles even courted the lowly American League Washington Senators in 1956, but turned its attention to the Dodgers when it appeared O'Malley might be receptive to a move if his negotiations with New York politicians proved fruitless.

O'Malley met with Los Angeles officials following the 1956 World Series and he took a 50-minute helicopter ride on May 2, 1957 above the hills of Chavez Ravine, the site of an abandoned City housing project. O'Malley set the stage for a potential move by selling Ebbets Field and arranging a three-year lease on the property, which doomed the long-term potential of the ballpark. He also acquired from Chicago Cubs' owner Phil Wrigley the Los Angeles franchise of the Pacific Coast League (PCL) and the Wrigley Field ballpark facility located at 42nd Place and Avalon Boulevard. This property seemingly cleared the territorial rights for O'Malley and would be used as a bargaining chip in negotiating for the Chavez Ravine property. The PCL later would accept a $900,000 indemnity to be paid over three years for the invasion of its territory by the Dodgers and Giants.

During the first week of October 1957, there was uncertainty on both sides. O'Malley mulled over his options, and Los Angeles City Councilmember Rosalind Wyman wasn't sure whether the Dodger president was coming or whether she had enough votes from the City Council to extend the invitation. Both sides finally took the plunge and O'Malley arrived in Los Angeles on October 23. Wyman and Hahn offered their greetings at the airport. So did a process server, who handed O'Malley a summons on behalf of those opposed to the City's contract for Chavez Ravine.

The next few years would become the greatest challenge of O'Malley's life, navigating his dream through a series of legal hurdles and in the court of public opinion.

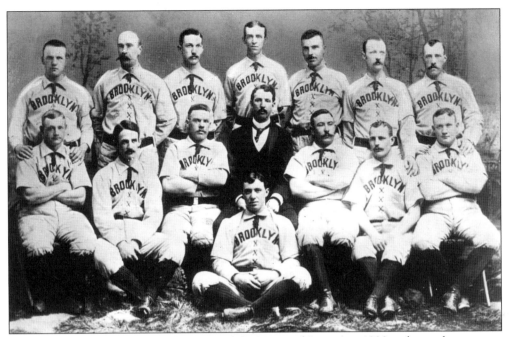

THE ORIGINAL DODGERS. Brooklyn joined the National League in 1890 and won the pennant with an 86-43 record. From left to right are (bottom) Mickey Hughes; (middle) George Pickney, Bob Caruthers, Hub Collins, Manager William McGuinnigle, Tom Daly, Bob Clark, and Tom Lovett; (top) Germany Smith, Pop Corkhill, Bill Terry, Dave Foutz, Darby O'Brien, Doc Bushong, and Oyster Burns.

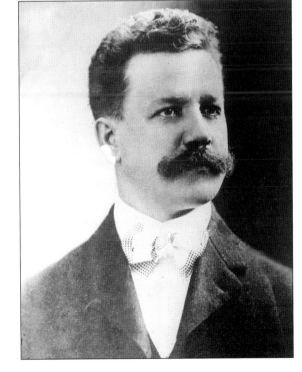

GRAND VISION. After starting as an office clerk in 1883, Charles Ebbets was elected president of the Brooklyn Dodgers in 1898. He sought to build a new ballpark in the former "Pigtown" section of Brooklyn, and he spent three years putting parcels of land together. His concrete and steel structure, Ebbets Field, cost $750,000 to build and opened on April 5, 1913.

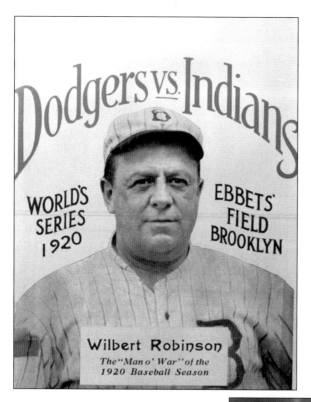

WILBERT ROBINSON. The Dodger manager appeared on the cover of the 1920 World Series program at Ebbets Field. Robinson, known as Uncle Robbie, piloted Brooklyn from 1914 to 1931 and his 1,375 victories rank third on the all-time Dodger career list behind Walter Alston (2,040) and Tommy Lasorda (1,599).

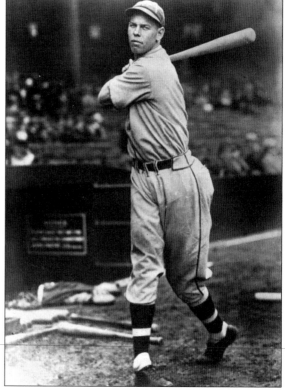

BABE HERMAN. The Dodgers didn't win a pennant from 1921 to 1940 and often finished in the second division of the National League. Outfielder Babe Herman was part of Brooklyn's "Daffiness Boys," whose colorful antics provided bright moments in otherwise dreary seasons. Herman compiled a lifetime .324 batting average in 13 seasons. He batted a career-high .393 with Brooklyn in 1930, but the Dodgers finished in sixth place.

THE INNOVATOR. In his five-year tenure as Dodger president beginning in 1938, Larry MacPhail hired radio broadcaster Red Barber and gave Babe Ruth his last major league job as a first base coach. MacPhail introduced night baseball to the major leagues and restocked a losing roster into a pennant contender under fiery Manager Leo Durocher. Brooklyn won the pennant in 1941. When he accepted a commission in the Army during the 1942 season, MacPhail was replaced by a former classmate from Michigan Law School, Branch Rickey.

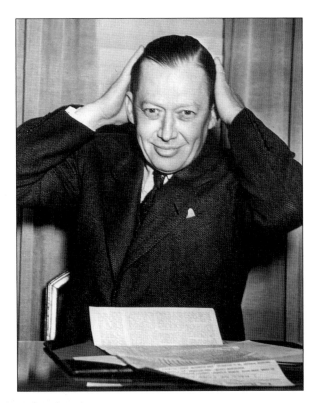

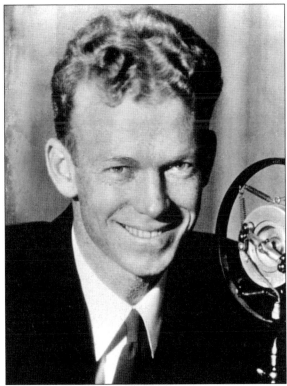

THE CATBIRD SEAT. Hall of Fame broadcaster Walter "Red" Barber was the popular voice of the Brooklyn Dodgers from 1939 to 1953. Barber's "one man in the booth" philosophy carried over to his successor Vin Scully, whom Barber mentored when the Fordham University product joined the ball club in 1950. Without a color commentator at his side, Barber felt his broadcasts could be interpreted as a conversation with a fan listening on the radio or television.

13

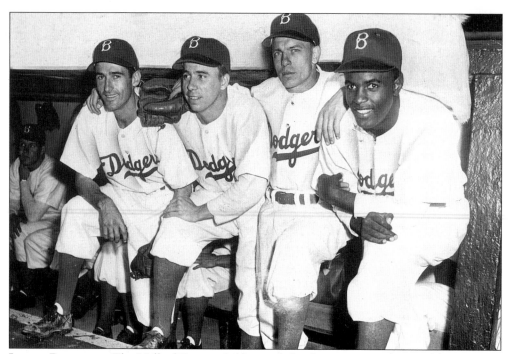

JACKIE ROBINSON. The Hall of Fame infielder made his historic major league debut in 1947 and became the first black player to appear in the major leagues in the 20th century. From left to right, John "Spider" Jorgensen, Pee Wee Reese, and Eddie Stanky join Robinson in the Dodger dugout. Robinson batted .297 in 151 games in 1947 and became baseball's first Rookie of the Year, an award that today bears his name.

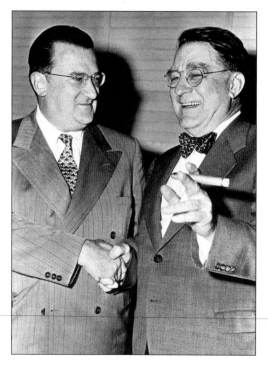

PASSING THE TORCH. Branch Rickey shakes hands with Walter O'Malley, who succeeded him as Dodger president on October 26, 1950. Rickey was the originator of baseball's farm systems during his tenure with the St. Louis Cardinals in the 1930s and he signed Jackie Robinson to his first professional contract in 1945. O'Malley and his son Peter kept the Dodgers under their family's ownership until 1998.

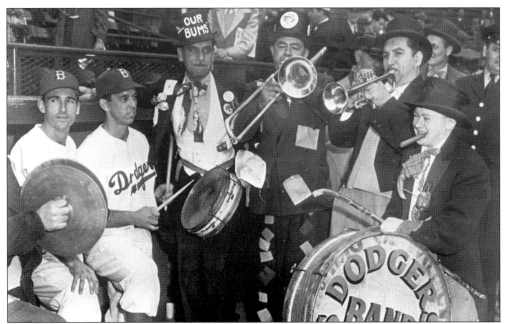

FLATBUSH FAVORITES. Along with the Dodger "bum" character made famous by *New York Herald* cartoonist Willard Mullin, the Brooklyn "Sym-phony Band" was a staple at Ebbets Field, providing informal entertainment and adding to the atmosphere at the cozy ballpark.

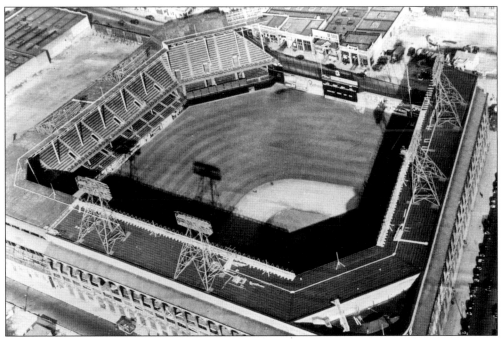

EBBETS FIELD. The ballpark was built in 1913 with an original seating capacity of more than 25,000 and included a tile-inlaid entrance rotunda. A neighborhood sprouted around the ballpark, eventually limiting the number of available parking spaces for the fans. The Dodgers began exploring possible sites for a new facility following World War II.

THE ONE AND ONLY. After seven World Series losses from 1916 to 1953, the Brooklyn Dodgers won their only championship in 1955. In a thrilling seven-game classic, Brooklyn outlasted their October rivals, the New York Yankees, as catcher Roy Campanella (left) and pitcher Johnny Podres celebrate a 2-0 victory in the deciding final game at Yankee Stadium. Left fielder Sandy Amoros preserved Podres's shutout in the sixth inning with a running one-handed catch of Yogi Berra's slicing fly ball, which Amoros turned into a double play.

INTERNATIONAL APPEAL. Following the 1956 season, the National League champion Dodgers embarked on a 19-game goodwill tour of Japan. On the cover of the exhibition game program is Dodger right-hander Don Newcombe, who went 27-7 during the regular season to win both the National League MVP and Cy Young Awards. The Dodgers would return to Japan in 1966 and 1993.

TELEPHONE HUbbARD 2-8088
2-8679

TIM McAULIFFE
INC.
Quality Athletic Equipment
24 LINCOLN STREET at SUMMER ST.
BOSTON, MASS.

December 11 1957

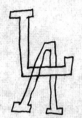

Mr Arthur Patterson
Los Angeles Dodgers
435 East 42nd Place
Los Angeles California

Dear Art:

Thank you for your letter, I am making up two new L A's for
Buzzie, I will send them to the Brooklyn office.

I will design them in the upper corner to show you what I mean,
one will be identical with the LA I gave you only larger, and
the other which is designed has the lower bar of the L, acting
as the cross bar of the A.

Dick Young happened to say that some one in the Brooklyn
organization was thinking of it this way, so I thought I'd at
least let them see how it looked. Personally I like the two
letters standing out by themselves, in the monogram.

I do hope they will make an early decision, so I can put in a
large stock of them, many West Coast fans are starting to
write in, and I will not send them any till I have the official
design.

Once I have it Art, you can start telling the fans who phone
or write in to get in touch with us, the price will be the same
as last year for individuals, $5.50 postpaid to them, advise
them to be sure of their size.

Again thanks and best wishes to you and your's for a very
Merry Christmas, and the best year the Dodgers ever had.

Sincerely,

Tim

A STITCH IN TIME. The Dodgers announced their intention to move to Los Angeles in the first week of October 1957. But one month later, their sporting goods manufacturer wasn't sure of the new cap design and offered two versions. The hand-drawn option shown on the upper right-hand corner of this letter to Dodger publicity director Red Patterson was picked over the "monogram" suggestion.

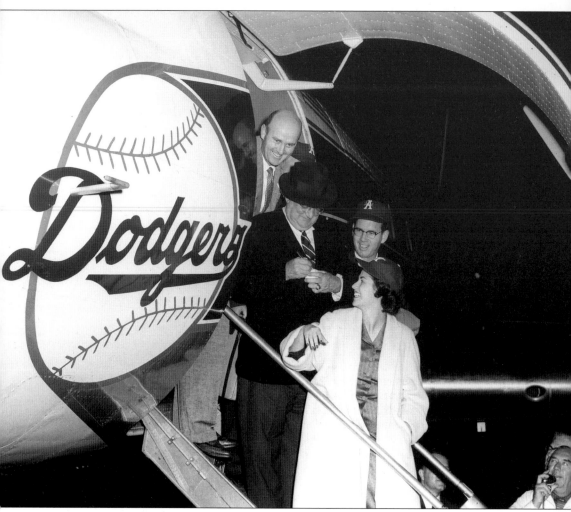

WESTWARD HO. Dodger president Walter O'Malley is welcomed upon his arrival in Los Angeles on October 23, 1957 by City Councilman Gordon Hahn, County Supervisor Kenneth Hahn, and Councilwoman Rosalind Wyman. O'Malley was also served with a summons at the airport on behalf of those opposed to the City's contract for the Chavez Ravine land, the first of many legal and political challenges on his way to building a new ballpark.

Two
The Coliseum Years

There wasn't any trouble when the new Los Angeles Dodgers looked for customers to purchase season tickets in 1958. In fact, eager Southern California baseball fans were willing to pay for their packages in advance, rather than through an installment plan as was the custom in Brooklyn.

But the Dodgers weren't sure which ballpark to choose—the tiny confines of a 22,000-seat baseball park or a cavernous 100,000-seat landmark better known for its football and track events.

The Los Angeles Angels of the Pacific Coast League made Wrigley Field their home from 1925 until relocating to Spokane in 1958 to make room for the Dodgers. They left behind a suitable ballpark for baseball, but the capacity could only be increased to 23,600 seats, which would be 10,000 seats fewer than the capacity of the just abandoned Ebbets Field in Brooklyn.

In mid-January, O'Malley completed negotiations with the Los Angeles Coliseum Commission for a plan that would enable a baseball diamond to be located on the west end of the Coliseum and not remove any physical properties of the historic and distinctive structure already used for USC and UCLA college football, along with the NFL's Los Angeles Rams.

When Kenneth Hahn first suggested the Coliseum for use by the Dodgers, he was voted down, 8-1, by his fellow commissioners. His opponents did not think the landmark originally built for the 1932 Olympics could be used for baseball. Hahn asked Pepperdine College baseball coach John Scolinos to measure the Coliseum's field in an attempt to prove baseball could be played there. Edwin Pauley, co-owner of the Los Angeles Rams, commissioned architect William Beckett for $5,000 to see if the Coliseum could be adapted for the Dodgers. Once Beckett signed off, the Commission changed its mind and authorized use of the Coliseum

The first modification under O'Malley's plan was a 42-foot-high screen that was erected in left field, in part to balance the relatively short 251-foot distance down the line. A press box area was added in the stands, along with three additional banks of lights and a removable screen on the north side of the Coliseum. O'Malley also pledged to guarantee an annual $300,000 rental fee, the highest ever paid by a baseball club.

More than 78,000 fans witnessed the Dodgers' first game in Los Angeles on April 18, 1958. And they held on for a 6-5 victory over the San Francisco Giants, something Dodger executive Buzzie Bavasi considered crucial in terms of first impressions.

"I think it was the most important game of all the time we were at the Coliseum," Bavasi said. "The fans of Los Angeles were looking for a winner, something to hang their hats on. We had to give the fans something they wanted—a winner."

The Dodgers struggled to a seventh-place finish in 1958, and a public referendum debate whether to approve the City's contract with O'Malley and the Chavez Ravine property turned into a major distraction. Los Angeles voters narrowly approved the Proposition B measure and the Dodger Stadium project was spared.

Early in the 1959 season, an exhibition game between the Dodgers and New York Yankees on May 7 formed a lasting bond between both players and fans. The rich history of the Brooklyn ball club featured Roy Campanella, the three-time National League MVP whose January 1958 auto accident left him paralyzed and unable to join his teammates for their first season on the West Coast. The organization staged a benefit game in his honor and a crowd of 93,103 paid tribute to a Dodger they never saw play, something Campanella never forgot during an inspirational life that lasted until 1993.

By the summer of 1959, the court battles continued, but the Dodgers' luck changed on the field. Shortstop Pee Wee Reese was now a coach, replaced by rookie Don Zimmer, whose subsequent batting struggles meant an audition for Maury Wills, promoted from Triple-A Spokane. Carl Erskine, the winning pitcher in the Dodgers' first game at the Coliseum, stepped aside and retired in June due to arm troubles. That opened the door for rookie Roger Craig, who teamed with fellow rookie Larry Sherry on an incredible second-half stretch that kept the Dodgers in contention. The second half also featured an 18-strikeout game by Sandy Koufax and the emerging presence of Southern California native Don Drysdale, who led the staff with 17 victories.

If heartbreak marked Brooklyn's attempts at postseason success, Los Angeles savored its beginner's luck. The Dodgers finished in a regular-season tie with the Milwaukee Braves, but unlike the painful 1946 and 1951 playoff defeats, the Dodgers won the tiebreaker and advanced to the World Series.

The 1959 Fall Classic featured the Dodgers and Chicago White Sox playing in front of three crowds of more than 92,000 fans, a major league attendance record. The Dodgers defeated the White Sox in six games and Los Angeles suddenly owned a World Championship team.

When the Dodgers published their 1960 yearbook, the cover image wasn't of Series MVP Larry Sherry, who posted two victories and two saves, or the clutch hitting of infielders Gil Hodges and Charlie Neal. Instead, it was a model of the Dodger Stadium, reminding fans of the organization's grand vision.

The honeymoon between the Dodgers and the Coliseum wore off during the 1960 and 1961 seasons as construction delays for the new ballpark unexpectedly extended their stay. And the roster turnover featured the departures of Brooklyn favorites such as Hodges, Carl Furillo, and Clem Labine.

Torrential rains hit Southern California in February 1962, causing $500,000 in damage to the topsoil and threatening the opening of Dodger Stadium. O'Malley remained committed to the scheduled April 10 opener, even though Angels owner Gene Autry offered use of the old Wrigley Field, where the American League team played its inaugural 1961 season. Both the Dodgers and Angels would play the 1962 season in the new ballpark, although the Angels would call their home "Chavez Ravine" instead of Dodger Stadium on its promotional and ticket materials.

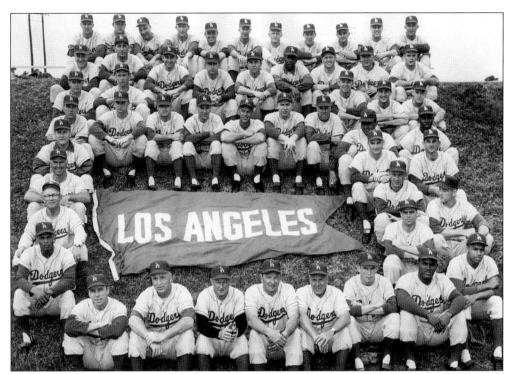

CHANGING CAPS. For the 11th consecutive season, the Dodgers reported to spring training in Vero Beach, Florida in 1958. While the uniforms remained the same, along with the majority of the playing roster, the "LA" on their hats revealed the Dodgers would not be returning to Brooklyn after six weeks.

L.A.'S THE PLACE. Relief pitcher Clem Labine gets ready for Hollywood by posing in spring training with 15 baseballs arranged in the "LA" formation. The right-hander played for Brooklyn and Los Angeles from 1950 to 1960.

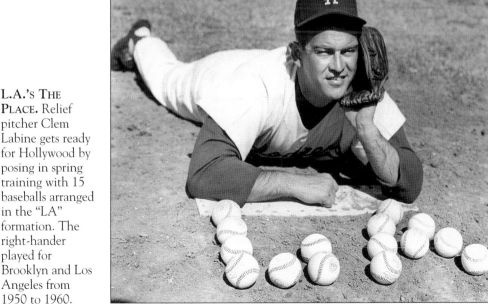

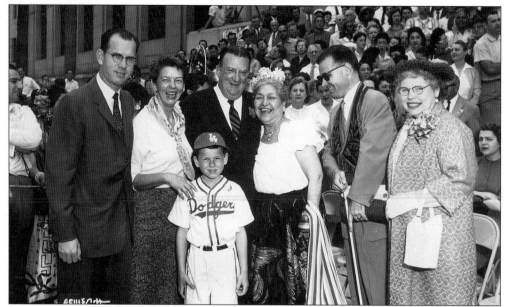

CITY HALL CEREMONY. Dodger president Walter O'Malley enjoys Opening Day 1958 festivities, which included costumed señoritas cracking confetti-filled eggshells over the heads of Dodger manager Walter Alston and his players for good luck. In the front row wearing his Dodger uniform is seven-year-old James Hahn, the future mayor of Los Angeles.

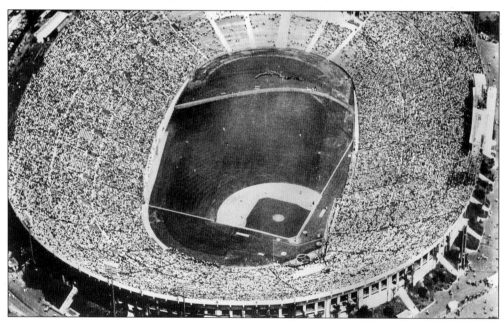

PLAY BALL. A record crowd of 78,672 watched the Dodgers' first game in Los Angeles on April 18, 1958. Originally, Coliseum Commissioners voted 8-1 against the Dodgers playing at the city landmark. But Supervisor Kenneth Hahn and Pepperdine College baseball coach John Scolinos measured the Coliseum field to prove baseball could be played there. Once architect William Beckett gave his approval, the commission changed its mind and authorized use of the Coliseum by the Dodgers.

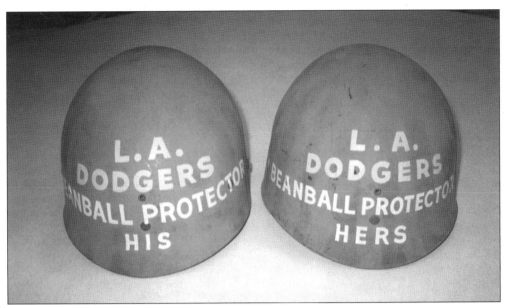

HOLLYWOOD HELMETS. There were many Hollywood personalities in attendance for the Dodgers' first home game at the Los Angeles Coliseum in 1958, including Chuck Connors, Alfred Hitchcock, Gregory Peck, Nat King Cole, Buddy Rogers, Groucho Marx, George Jessel, Gene Autry, Jimmy Stewart, Lauren Bacall, and Tennessee Ernie Ford. Behind the Dodger dugout, comedian Ray Bolger and his wife wore "His" and "Hers" surplus Army helmets on which he had painted "L.A. DODGERS BEANBALL PROTECTOR."

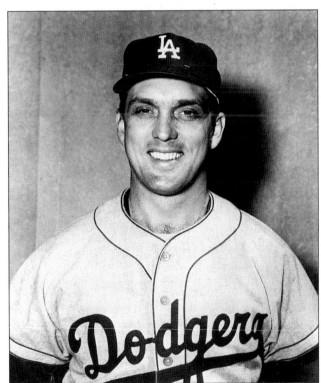

HIGH HONOR. Carl Erskine pitched two no-hitters and set a World Series single-game strikeout record during his tenure with the Brooklyn Dodgers, which began in 1948. The Indiana native was near the end of his career at age 31 in 1958 due to arm troubles when tapped by Manager Walter Alston to start the Dodgers' first home game in Los Angeles against the San Francisco Giants on April 18. Erskine pitched eight strong innings and picked up the decision in the Dodgers' 6-5 victory.

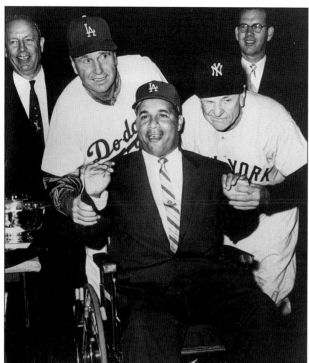

ROY CAMPANELLA NIGHT. The Hall of Fame catcher was paralyzed in an auto accident in January 1958. Although he never played on the West Coast, a special night in his honor and exhibition game between the Dodgers and New York Yankees on May 7, 1959 drew a record crowd of 93,103 at the Los Angeles Coliseum. During pre-game ceremonies, the three-time National League MVP poses with the managers, Walter Alston, and the Yankees' Casey Stengel.

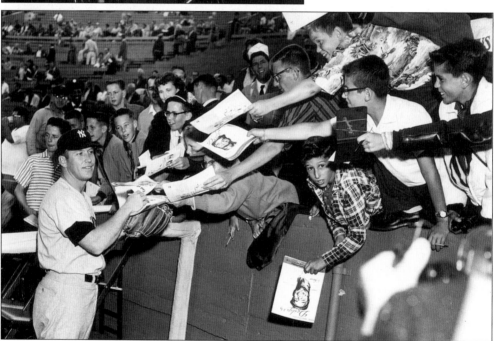

YANKEE SPIRIT. Outfielder Mickey Mantle signs autographs for fans prior to the special Dodgers-Yankees exhibition game on "Roy Campanella Night" at the Los Angeles Coliseum. The Yankees flew to Los Angeles following a day game in Kansas City; the Dodgers arrived after their afternoon encounter at San Francisco. Campanella appeared in five World Series in his career—all against the Yankees—from 1949 to 1956.

24

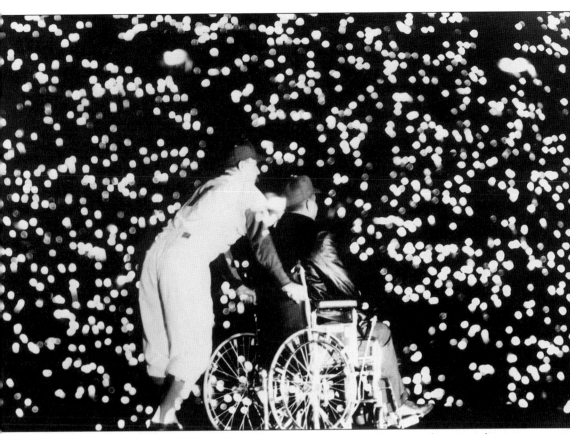

FOREVER TEAMMATES. In one of the most dramatic scenes in Los Angeles sports history, former Dodger captain Pee Wee Reese escorts Roy Campanella onto the field at the Los Angeles Coliseum during a Dodgers-Yankees exhibition game played in his honor. Following the top of the fifth inning, the stadium lights were dimmed and fans were asked to strike a match in silent prayer for "Campy."

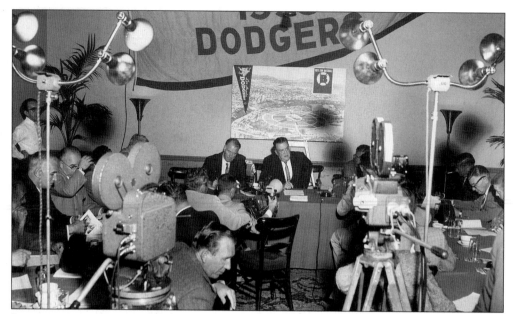

PROPOSITION B. A public referendum threatened the City contract that transferred the Chavez Ravine property to the Dodgers in exchange for the Wrigley Field site that Walter O'Malley had purchased from the old Los Angeles Angels of the Pacific Coast League in February 1957. A five-hour telethon in support of Proposition B was held two days before the election and featured many local business leaders and Hollywood celebrities. The Proposition B narrowly passed on June 3, 1958, although additional legal challenges delayed the Dodgers from proceeding with the construction of a new ballpark.

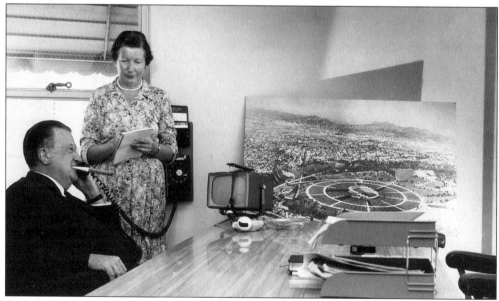

FOCUSED ON FUTURE. On August 20, 1958, Walter O'Malley sits in his Wilshire Boulevard office with his secretary, Edith Monak. On his desk is a photo of the Dodger Stadium model. O'Malley stayed at the Statler Hotel when he arrived on the West Coast to better supervise the construction of the new ballpark.

SPARKPLUG. The Dodgers promoted 26-year-old Maury Wills from Triple-A Spokane during the 1959 season and the shortstop batted .260 in 83 games. Wills learned to become a switch-hitter under Manager Bobby Bragan at Spokane, and he received encouragement from Los Angeles coach Pete Reiser, who pulled Wills from a sophomore slump in 1960 by working two extra hours per day before the regular practice during a two-week period at the Coliseum, a tutorial that Wills credits for saving his career.

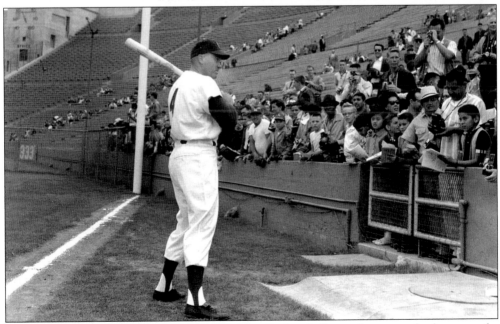

THE DUKE. Edwin "Duke" Snider, the Brooklyn Dodgers' all-time home run leader, poses for fans on Camera Day at the Los Angeles Coliseum. The dimensions of the converted football field didn't favor Snider, whose home run total dipped from 40 in 1957 to 15 in 1958. The center field fence was 425 feet from home plate and the right-field power alley was 440 feet away.

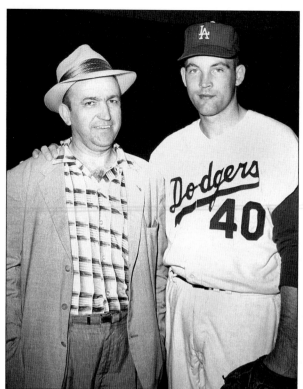

STAN WILLIAMS. The hard-throwing right-hander was recommended by Manual Boody, a *Rocky Mountain News* sportswriter, and was signed by Dodger scout Bert Wells in June 1954. Williams won 57 games with the Dodgers from 1958 to 1962.

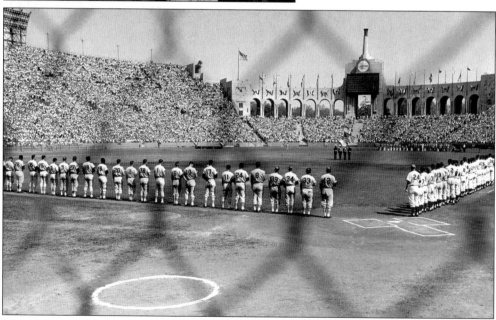

WORLD SERIES. The Dodgers and American League champion Chicago White Sox line up for the national anthem at the Los Angeles Coliseum. The ballpark hosted crowds of more than 92,000 in each of the three games, a major league record. It was also the first time the Dodgers faced a World Series opponent other than the New York Yankees since 1920, when they lost to the Cleveland Indians, 5-2, in a best-of-nine format.

UNLIKELY HERO. Outfielder Chuck Essegian played in just 24 games during the regular season for the Dodgers in 1959. But the former Stanford University fullback provided a spark off the bench with two home runs as a pinch-hitter in the World Series against the Chicago White Sox as the Dodgers won the title in six games.

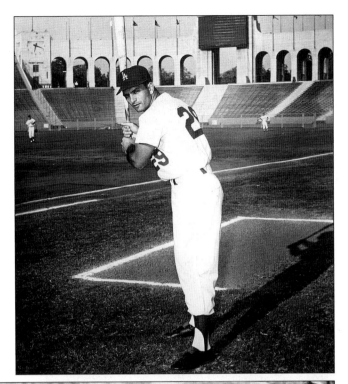

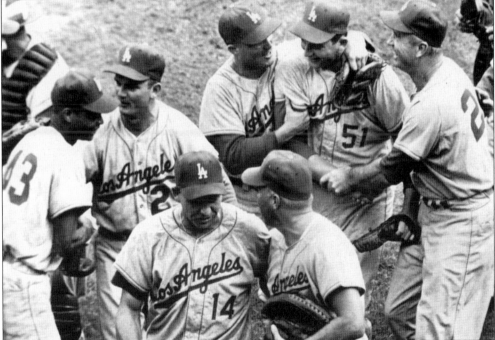

CELEBRATION. Rookie relief pitcher Larry Sherry played a part in every Dodger triumph during the 1959 World Series with two victories and two saves against the Chicago White Sox. The World Series MVP was one of three graduates from Los Angeles Fairfax High School to appear in the Fall Classic, along with the Dodgers' Chuck Essegian and Chicago pitcher Barry Latman.

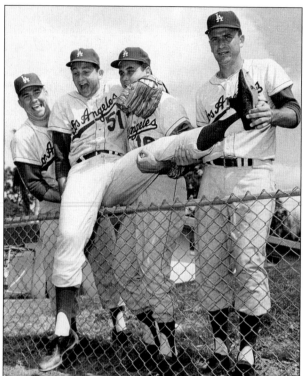

SPRING FORWARD. Larry Sherry, hero of the 1959 World Series, receives a playful toss out of the bullpen in spring training as he launched a campaign to become one of the team's starting pitchers. From left to right are Jack Smith, Sherry, Ron Perranoski, and Ed Roebuck. But Sherry would remain primarily a relief pitcher during his Dodger tenure through 1963.

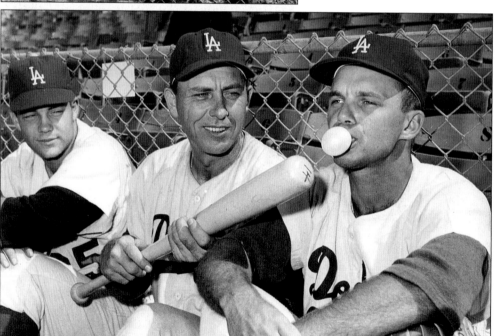

ON THE BUBBLE. From left to right, Doug Camilli watches as veteran Gil Hodges takes aim at Dick Tracewski's chewing gum during a break in spring training in 1961. It would be the 16th and final season in a Dodger uniform for Hodges, who joined the expansion New York Mets in 1962 as a player. Later he returned to Shea Stadium and managed the 1969 World Champion Mets.

BUZZIE AND FRESCO. Emil J. "Buzzie" Bavasi served as the Dodgers' executive vice president and general manager from 1950 to 1968. At the Coliseum, Bavasi confers with Lafayette "Fresco" Thompson, the Dodgers' vice president in charge of minor league operations. Thompson, a former major league infielder, was a member of the Dodger front office from 1940 until his death in November 1968, five months after Bavasi left the Dodgers to take over the expansion San Diego Padres franchise.

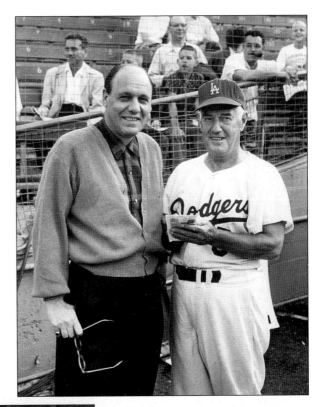

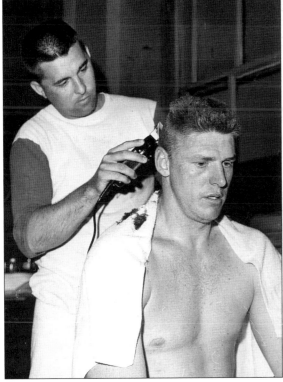

HONDO'S HAIRCUT. Frank Howard was a standout in both basketball and baseball at Ohio State University. The Dodgers signed the two-sport star to a $108,000 bonus in 1958. In his first full season with the Dodgers in 1960, Howard batted .268 in 117 games with 23 home runs and 77 RBI.

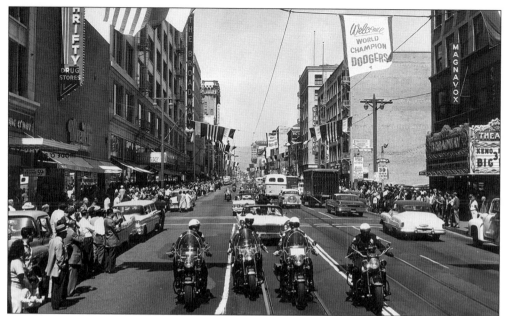

VICTORY PARADE. The 1959 World Champions enjoy a parade through downtown Los Angeles prior to Opening Day 1960. Decorations were placed on various landmarks and street posts as the Dodgers mounted a tremendous turnaround from its debut on the West Coast, a seventh-place showing in 1958.

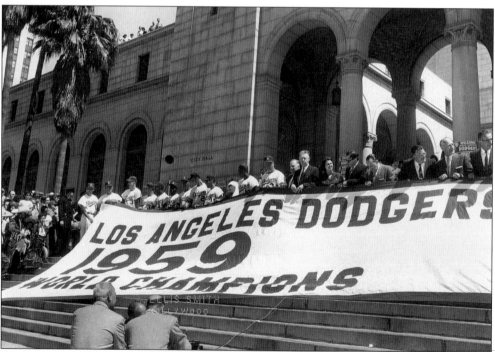

BANNER NEWS. Back on the steps of City Hall, the Dodgers celebrate a World Series title in only their second year in Los Angeles. Brooklyn fans had to wait until 1955 for the Dodgers' only championship in New York. Los Angeles would capture two additional titles by 1965.

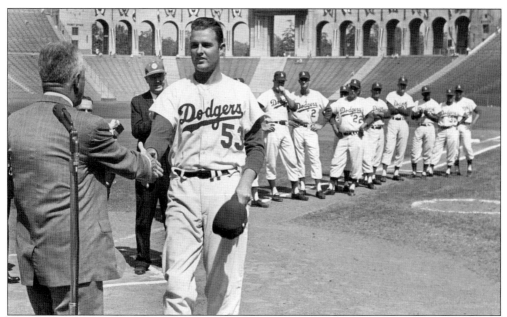

DON DRYSDALE. Right-hander Don Drysdale shakes hands with Baseball Commissioner Ford Frick on Opening Day 1960. The Southern California native broke into the majors with Brooklyn at age 19 in 1956. Drysdale went 17-13 with a 3.45 ERA and 15 complete games in 1959 and won the first of his three National League strikeout crowns by fanning 242 batters in 271 innings.

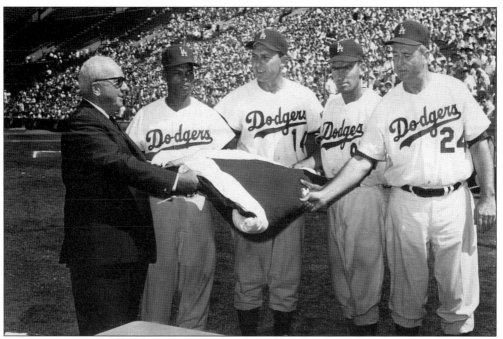

L.A.'s FIRST FLAG. Opening Day 1960 ceremonies at the Los Angeles Coliseum included the presentation of World Series rings, along with the championship banners. From left to right are National League President Warren Giles, infielder Charlie Neal, first baseman Gil Hodges, outfielder Wally Moon, and Manager Walter Alston.

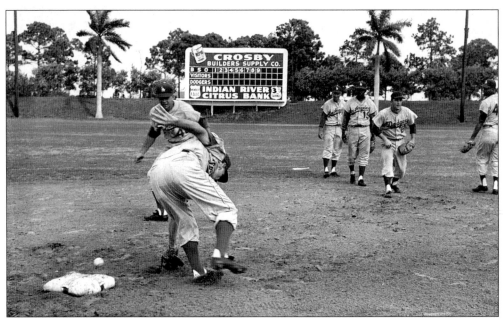

THE HOT CORNER. Despite their championship in 1959, it was back to business for the Dodgers four months later in spring training as infielders work on ground balls. The Dodgers moved into their Vero Beach, Florida headquarters in 1948, and the 5,000-seat Holman Stadium was dedicated in 1953.

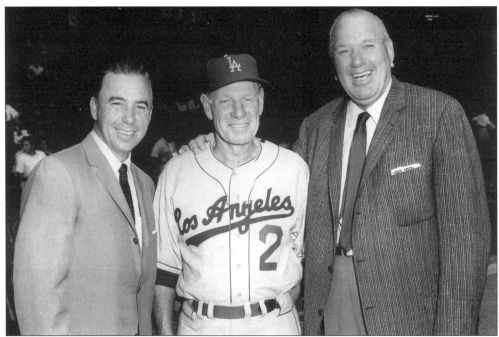

HALL OF FAME TRIO. Baseball's "Game of the Week" announcers Pee Wee Reese and Dizzy Dean flank Dodger coach Leo Durocher at Connie Mack Stadium in Philadelphia. Reese appeared in 59 games with Los Angeles in 1958 and spent one season as a coach in 1959. He became a broadcaster with CBS in 1960. Durocher was Reese's first manager with Brooklyn in 1940.

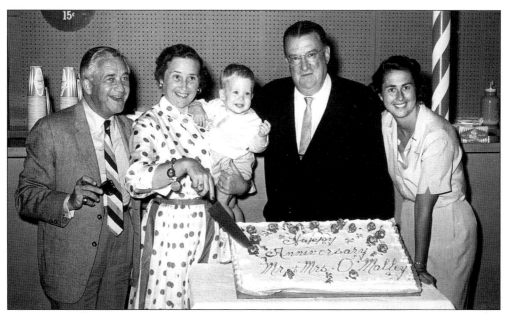

ICING ON THE CAKE. Celebrating a wedding anniversary of Walter O'Malley and his wife, Kay, are Hollywood director Mervyn LeRoy (far left) and Los Angeles City Councilwoman Rosalind Wyman. It was LeRoy's suggestion that O'Malley use a green vegetable dye on the eve of Dodger Stadium's grand opening in 1962 to paint the brown patches in the outfield caused by heavy rains that spring.

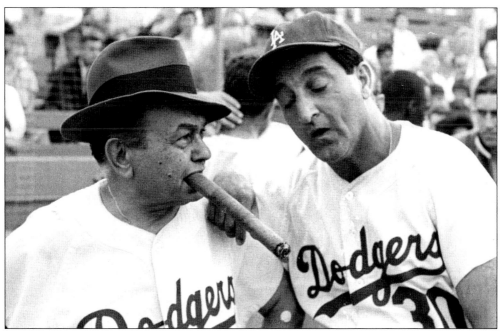

IN THE STARS. Actors Edward G. Robinson and Danny Thomas participate in the 1960 Hollywood Stars game at the Los Angeles Coliseum. This tradition dated back to the 1940s with Southern California's two Pacific Coast League franchises, the Hollywood Stars and Los Angeles Angels.

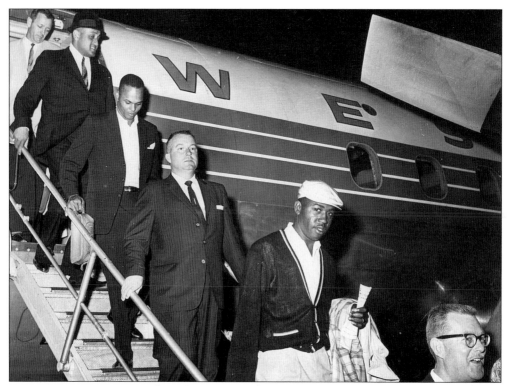

ANOTHER ARRIVAL. Jim Gilliam (wearing cap) is ready for spring training following a flight to Vero Beach, Florida in 1961. At the top of the stairs is pitcher Don Newcombe (wearing hat), who was attempting to make a comeback. Newcombe pitched for Brooklyn and Los Angeles from 1949 to 1958 and spent three seasons with Cincinnati. He eventually played the 1962 campaign in Japan as a first baseman with the Chunichi Dragons, hitting 12 home runs in 81 games.

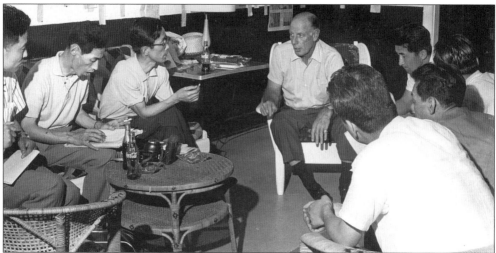

LEO THE LIP. Dodger coach Leo Durocher holds court in the Dodgertown press room in 1961 with members of the Japanese media covering the Tokyo Giants spring visit to Vero Beach, Florida. During his Hall of Fame career, Durocher managed the Brooklyn Dodgers (1939–1946, 1948) and later coached with Los Angeles (1961–1964).

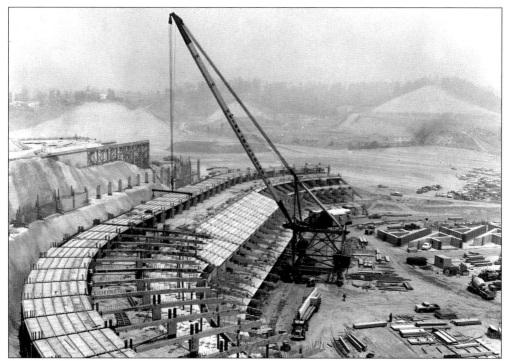

BUILDING FOR TOMORROW. A groundbreaking ceremony at Chavez Ravine was staged on September 17, 1959. Construction for the actual ballpark began after Labor Day 1960 and Dodger Stadium opened in 1962.

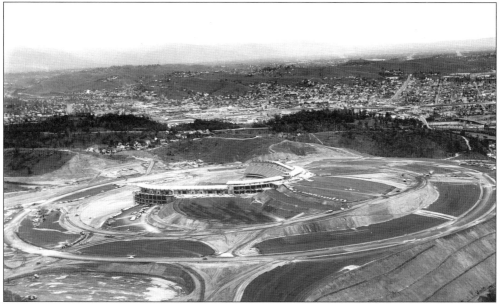

THE DREAM BALLPARK. The 56,000-seat Dodger Stadium was only the second privately financed major league ballpark in the 20th century and the first since Yankee Stadium in 1923. It was designed by architect Emil Praeger and built by Vinnell Constructors of Alhambra, which specialized in concrete projects such as parking lots and freeway interchanges.

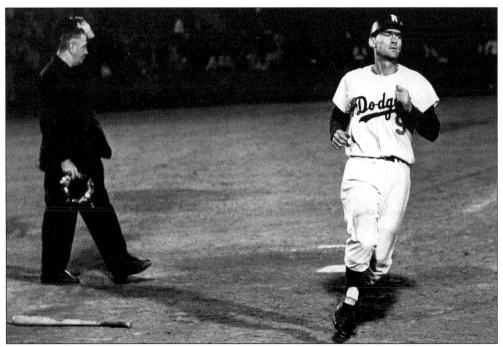

THE FINAL RUN. Outfielder Wally Moon scored the Dodgers' final run at the Los Angeles Coliseum during a 3-2 victory in 13 innings against the Chicago Cubs on September 20, 1961. Upon his arrival to the Dodgers in 1959, the veteran took advantage of the ballpark's relatively modest 320-foot distance to the left field power alley, and his opposite-field home runs deposited over a 40-foot high screen were dubbed "Moon Shots."

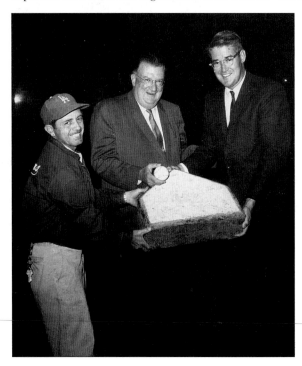

COLLECTION PLATE. Following the Dodgers' final game at the Los Angeles Coliseum, team president Walter O'Malley holds the home plate along with his son Peter and Dodger groundskeeper Chris Duca. The plate was earmarked for a future Dodger museum.

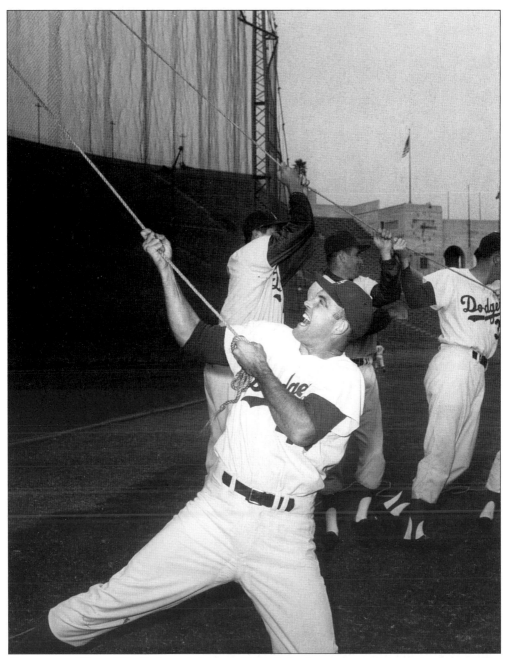

CRUMBLING WALL. The Dodger pitching staff didn't shed many tears when it was time to leave the Los Angeles Coliseum, their home from 1958 to 1961. Right-hander Stan Williams takes great joy helping pull down the 40-foot-high screen in left field following the final game.

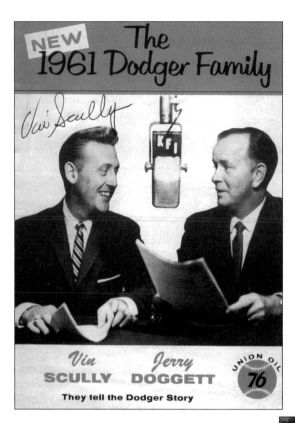

VIN AND JERRY. Although the Dodgers were leaving the cavernous Los Angeles Coliseum, transistor radios to listen to the play-by-play were still required in the new ballpark thanks to popular broadcasters Vin Scully and Jerry Doggett. Their 32-year partnership from 1956 to 1987 would be the longest in baseball history.

A SNEAK PEEK. In December 1961, the Dodgers previewed their new Dodger Stadium. From left to right, Manager Walter Alston, Vice President Dick Walsh, infielder Ron Fairly, catcher Norm Sherry, and pitcher Larry Sherry stand on the Reserved Level. Some 21,000 pre-cast concrete units, weighing up to 32 tons, were lifted into the stadium's structural framework by giant cranes

THREE
Dodger Stadium

The creation of Dodger Stadium would become the jewel in Walter O'Malley's four-decade career in the major leagues. It was the first privately financed baseball venue since Yankee Stadium in 1923, and its fundamental amenities were designed for the fan, including a revolutionary concept of multi-level parking lots and an unobstructed view from any of the 56,000 seats.

Chavez Ravine was a difficult construction site because of a network of washes, gullies, and gulches that were interlaced with hills and twisting roads. Elevations in the ravine ranged from 400 feet to 700 feet above sea level. In order to compensate for this rough terrain, more than 8 million cubic yards of earth was moved to reshape the area. The steeply terraced bowl of the towering hillside site became an integral part of the main grandstand structure and located the stands on a slope in the shelter of the U-shaped hill.

The ballpark was designed by Emil Praeger, a distinguished Navy captain who was in charge of all engineering projects for the Department of Parks in New York City. Praeger didn't have a chance to build a new ballpark in Brooklyn, but O'Malley witnessed Praeger's capacity when the two teamed to build a 5,000-seat facility at the Dodgers' spring training headquarters in Vero Beach, Florida. Holman Stadium opened in 1953 and remains the centerpiece of the modern-day training complex.

The Proposition B referendum in 1958, which challenged O'Malley's original agreement with the City to transfer ownership of Chavez Ravine, and further delays by opponents pushed back the actual construction of the stadium until after Labor Day 1960. O'Malley chose Vinnell Constructors of Alhambra to build the ballpark using Praeger's designs. And O'Malley wanted contractor-in-charge Jack Yount to personally supervise the project and feared dealing with another company could lead to delays with subcontractors. O'Malley wanted the ballpark to be made of concrete instead of steel.

The sparkling new Dodger Stadium opened in 1962 and provided the perfect stage for a ball club featuring players hitting their stride and enjoying the peak of their respective careers. Right-hander Don Drysdale won 25 games and the National League Cy Young Award. Maury Wills set a major league record with 104 stolen bases en route to league MVP honors, and Tommy Davis won the first of two consecutive batting crowns. His 230 hits and 153 RBI in

1962 remain single-season Los Angeles records. Sandy Koufax began a brilliant five-year run with a 14-7 campaign with a league-leading 2.54 ERA and the first of four career no-hitters. But circulation problems in his fingers sidelined Koufax after July 17 and the Dodgers sputtered in September, losing 10 of their final 13 games.

The 1962 season ended with heartbreak, a gut-wrenching loss to the Giants in a three-game playoff. Clinging to a 4-2 lead in the ninth inning of the third playoff game, the Giants erupted for four runs against relievers Ed Roebuck and Stan Williams. Coach Leo Durocher and other players questioned Manager Walter Alston for not using Don Drysdale in relief instead of saving him for the potential World Series opener against the Yankees.

The decision nearly cost Alston his job, but General Manager Buzzie Bavasi gave his skipper another chance and the Dodgers won the 1963 pennant, led by Koufax (25-5) and Drysdale (19-17). In their only October meeting with the Yankees during the 1960s, the Dodgers posted a stunning four-game sweep as Koufax struck out 23 batters in his two starts, including a single-game record of 15 strikeouts in the Series opener at Yankee Stadium.

The Dodgers finished tied for sixth with an 80-82 record in 1964 and retooled their starting rotation by acquiring left-hander Claude Osteen from the Washington Senators in exchange for outfielder Frank Howard. A superior pitching staff supported a popgun offense in 1965 as the Dodgers captured another pennant and World Series title. Just as the 1959 World Champions needed help from unlikely sources, the Dodgers discovered a catalyst in 30-year-old journeyman outfielder Lou Johnson, promoted from Triple-A after Tommy Davis suffered an ankle injury. Johnson would hit the game-winning home run in the deciding seventh game at Minnesota to support Koufax's shutout.

The team followed the same formula of pitching, speed and defense in 1966, but the upstart Baltimore Orioles stunned Los Angeles with a four-game sweep. It would mark the end of an era as Koufax announced his retirement due to arm troubles and Wills was traded to the Pittsburgh Pirates after he left the team without permission during its 1966 postseason goodwill exhibition tour of Japan.

Without Koufax and Wills, the Dodgers slipped to eighth place in 1967 and attendance dipped from 2.6 million to 1.6 million. In 1968, attendance dropped by another 100,000 during a seventh-place finish, although the season was highlighted by Drysdale's streak of 58$^2/_3$ scoreless innings and six consecutive shutouts.

The reversal of fortune wasn't alarming to O'Malley, who remained committed to owning the team and focusing on the overall landscape of Southern California and the world of sports entertainment.

"The novelty of the new stadium has worn off," O'Malley admitted in a 1969 interview with the *Los Angeles Times*.

> We wanted this to be a showplace, and it is, but we've been here eight years, and most people have seen it who want to. Our attendance, you see, was inflated in the early seasons. The fact is that it was much larger than our wildest hopes. But it couldn't go on. . . . Buses drop off loads of visitors here every day. They lean down and touch the grass, and walk out to the mound where Don Drysdale stands in those Vaseline commercials. And I have to hope that many of them will come back. But as the years go along, we're judged more and more as a baseball team. As in other baseball cities, our attendance will rise when a Drysdale pitches 58 scoreless innings or when we develop other great stars or when we get another guy with that word charisma. Attendance will also rise if we just have a team that plays well as a unit.

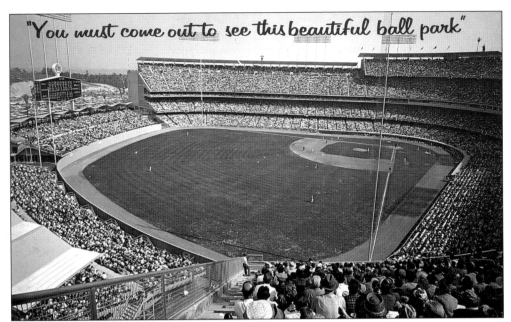

PRETTY AS A POSTCARD. This is the view from left field on April 10, 1962 as the Dodgers and Cincinnati Reds christened the new ballpark in front of 52,564. Although the Dodgers lost the game, 6-3, their venue became an instant tourist attraction as Los Angeles drew more than 2.7 million fans, a major league record.

THE ROAD HOME. All roads led to Dodger Stadium and more than 5 million fans watched both the Dodgers and American League Los Angeles Angels during the 1962 season. The Angels played at "Chavez Ravine" through the 1965 campaign.

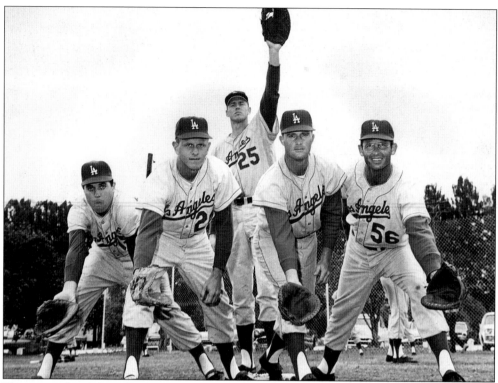

HOPEFULS. Candidates for first base prior to the 1961 season include, from left to right, Tim Harkness, Mel Corko, Frank Howard, Ron Fairly, and Lee Walls. By 1962, Fairly played the most games at the position (120), backed up by Harkness (59), Wally Moon (32), and Walls (11).

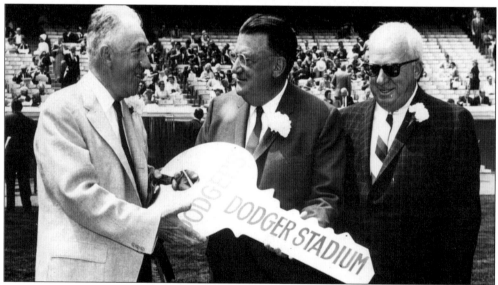

HOUSE KEY. Baseball commissioner Ford Frick and National League president Warren Giles present a commemorative key to Dodger president Walter O'Malley during a "grand opening" civic luncheon at Dodger Stadium on April 9, 1962. During the ceremonies, construction workers were still putting the finishing touches on the ballpark.

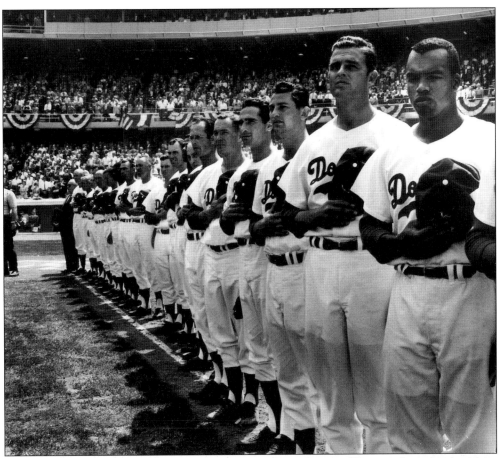

OPENING DAY LINEUP. The Los Angeles players and coaching staff line up along the third base line during the national anthem in the 1962 Dodger Stadium debut. The 1 p.m. game was started by Dodger left-hander Johnny Podres.

PETE REISER. The former National League batting champion with Brooklyn in 1941 was a coach on Manager Walter Alston's staff from 1960 to 1964. Injuries plagued Reiser throughout his career, including crashing into Ebbets Field's concrete outfield wall, which later was padded because of Reiser's mishaps.

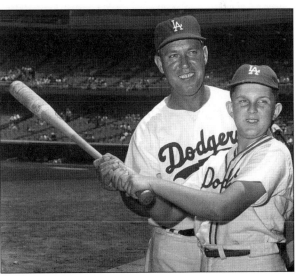

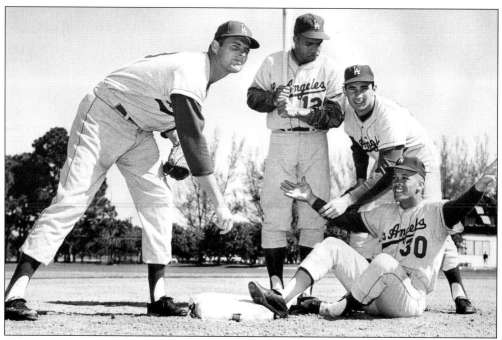

FRANCHISE PLAYERS. The Dodgers finished second in the National League in 1962, despite a 102-63 record, after dropping a three-game playoff with the Giants. From left to right, stars included league leaders Don Drysdale (25 wins, 232 strikeouts), Tommy Davis (.346 batting average), Sandy Koufax (2.54 earned run average), and Maury Wills (104 stolen bases).

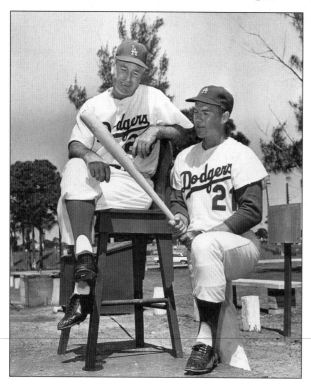

ANDY CAREY. The infielder played only one season with the Dodgers, batting .234 in a reserve role in 1962. But Carey left his mark on the Dodgers thanks to his camera. His candid clubhouse photos captured the fun of the Dodgers in their new ballpark.

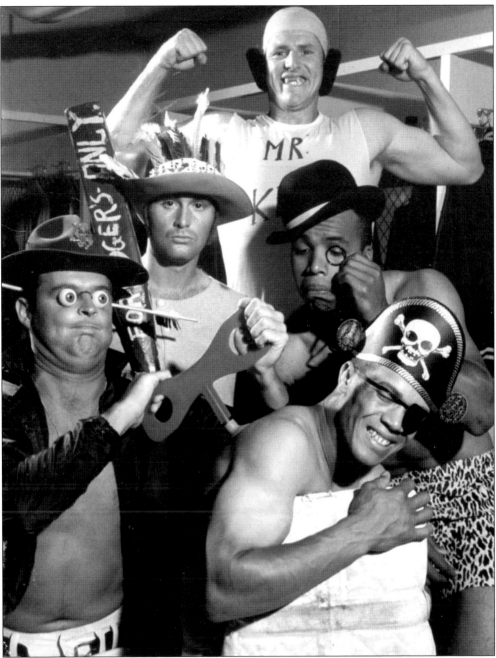

CLUBHOUSE FUN. During the 1962 season, infielder Andy Carey took pictures in the Dodger clubhouse, which later were published in a set of 20 snapshots available for fans at the souvenir stand. These costumed Dodger heroes include, from left to right, Don Drysdale, Ron Fairly, Frank Howard, Tommy Davis, and Maury Wills. Printed on Howard's T-shirt are the words, "Mr. Kleen," saluting the cartoon strongman on the label of a household cleaning product.

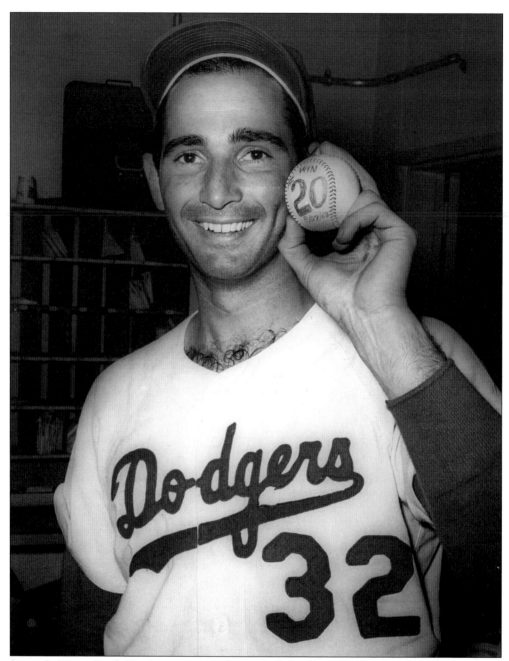

SANDY'S 20TH. Sandy Koufax poses with the baseball from his 20th victory on August 29, 1963. Koufax won his first career Cy Young Award that season, posting a 25-5 record and 1.88 earned run average, including 40 starts, 20 complete games, 11 shutouts, and 306 strikeouts in 311 innings.

DICK NEN. During the 1963 pennant race, the Dodgers received a boost from rookie first baseman Dick Nen, who hit a game-tying home run in the ninth inning during an eventual 6-5 victory in 13 innings at St. Louis on September 18. It was Nen's only career hit with the Dodgers. His son Robb Nen broke into the majors in 1993 and became a premier relief pitcher.

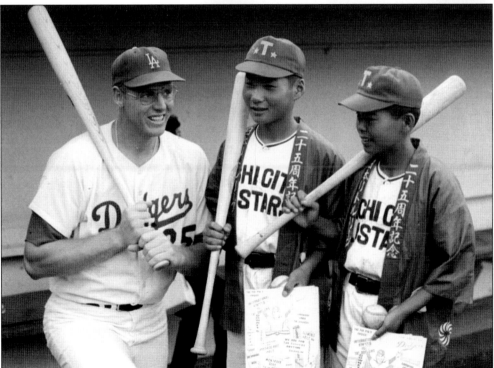

BIG FRANK. Dodger slugger Frank Howard poses in the dugout with two members of the Japan Little League All-Stars, Susumu Koto and Yukio Shishido. Howard hit a team-high 28 home runs in 1963. In the World Series, his Game 4 home run off New York's Whitey Ford traveled 430 feet and landed on the Loge Level of Dodger Stadium.

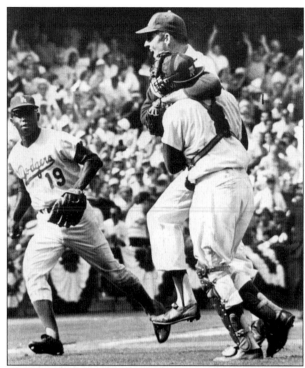

1963 WORLD SERIES. In the first Fall Classic at Dodger Stadium, Don Drysdale defeated the New York Yankees, 1-0, in Game 3. Drysdale bested New York right-hander Jim Bouton, who allowed a first inning run on a walk to Jim Gilliam, a wild pitch, and Tommy Davis' single off the shin of second baseman Bobby Richardson.

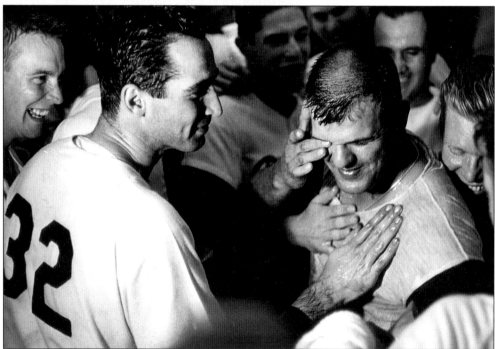

SWEET SWEEP. Basking in the afterglow of the Dodgers' 2-1 victory in Game 4 of the 1963 World Series is Sandy Koufax, who congratulates veteran infielder Bill "Moose" Skowron in the Los Angeles clubhouse. Koufax notched 23 strikeouts in his two World Series victories, including a single-game record mark of 15 in the Series opener at Yankee Stadium.

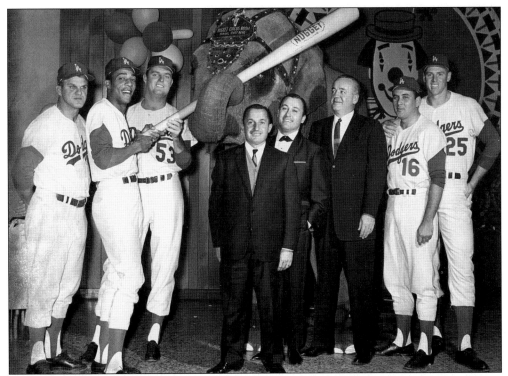

CIRCUS ACT. Following their 1963 championship, the Dodgers were also a hit in Las Vegas, appearing at the Nugget Casino in Sparks, Nevada. Los Angeles players include, from left to right, Bill "Moose" Skowron, Willie Davis, Don Drysdale, Ron Perranoski, and Frank Howard.

ATHLETE AND SOLDIER. Rookie outfielder Roy Gleason was promoted to the Dodgers at age 20 during the 1963 pennant race. Gleason hit a double in his only major league at-bat against the Phillies' Dennis Bennett on September 28 at Dodger Stadium. Gleason returned to the minor leagues and was drafted in 1967, becoming the only player with previous major league experience to serve in the Vietnam War. He received a Purple Heart, Bronze Star, and 14 overall military citations.

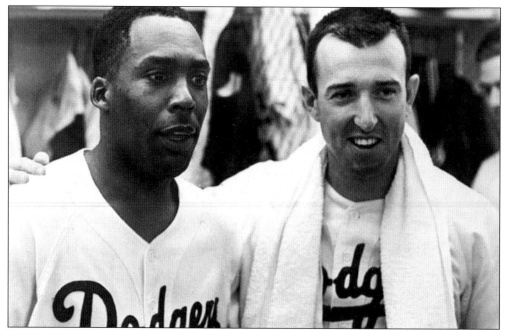

BATTERYMATES. The Dodgers acquired left-hander Claude Osteen, right, from the Washington Senators prior to the 1965 season in exchange for outfielder Frank Howard. Osteen, in the clubhouse with catcher John Roseboro, would win 147 games in nine seasons with the Dodgers.

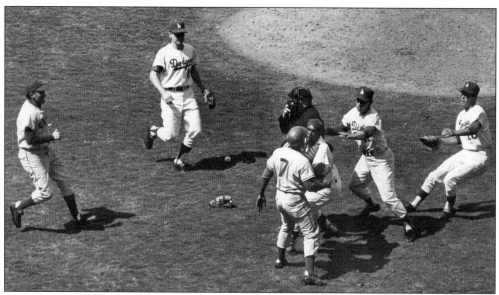

THE BRAWLGAME. Catcher John Roseboro is among the peacemakers during a benches-clearing incident at a Dodgers-Cubs game in Los Angeles on May 16, 1965. The melee broke out after pitcher Bob Miller hit Roberto Pena (7) with a pitch in the 10th inning. From left to right, Coach Alvin Dark, third baseman John Kennedy, and umpire Al Forman dash in front of Miller while first baseman Wes Parker is about to restrain his pitcher. Three months later, Roseboro would become involved in a famous incident with Giants pitcher Juan Marichal, who hit the catcher on the head with a bat in San Francisco.

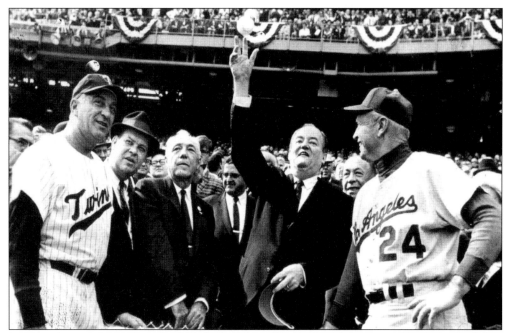

WORLD SERIES OPENER. Vice President Hubert Humphrey throws out the ceremonial first pitch prior to the 1965 World Series opener at Minnesota's Metropolitan Stadium. The Twins, led by Manager Sam Mele, were making their first postseason appearance. The Dodgers outlasted Minnesota in a thrilling classic, capturing the seventh and deciding game, 2-0, on a three-hitter by Series MVP Sandy Koufax.

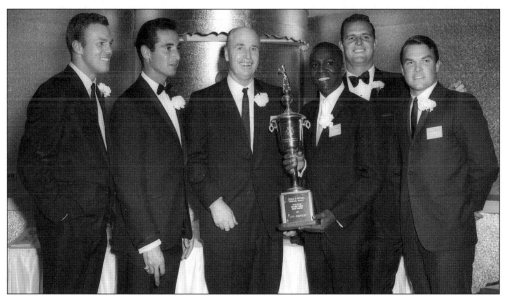

HONOR ROLL. At the 1965 banquet of the Los Angeles chapter of the Baseball Writers Association of America, several members of the Dodgers were honored, including, from left to right, first baseman Wes Parker, pitcher Sandy Koufax, Manager Walter Alston, outfielder Lou Johnson, pitcher Don Drysdale, and infielder Jim Lefebvre. Koufax pitched the only perfect game in franchise history on September 9 against the Cubs, the fourth no-hitter of his career.

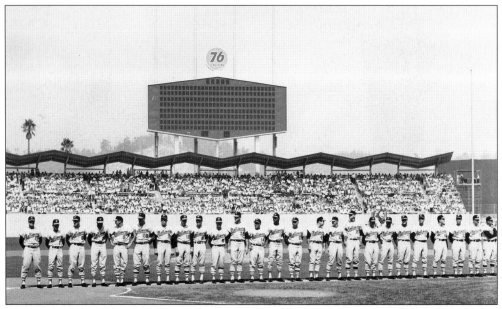

ORIOLE AMBUSH. The Dodgers returned to the World Series in 1966, but their offense didn't appear as the underdog Baltimore Orioles pulled off a four-game sweep. The Dodgers lost by scores of 5-2, 6-0, 1-0, and 1-0, failing to score in their final 33 innings.

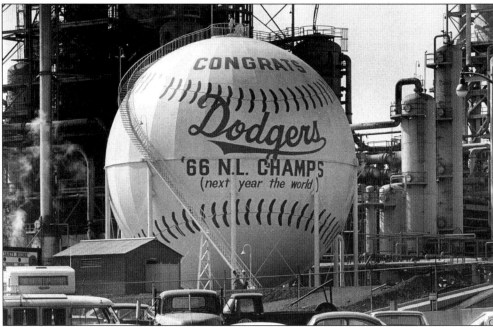

BIG DREAMS. The Union Oil Company created "the world's largest baseball" as a 70-foot-high tank at a Los Angeles refinery was specially painted following the 1966 World Series. There was reason for optimism as the Dodgers had appeared in the World Series in three of the past four seasons, including two World Championships in 1963 and 1965. But the retirement of pitcher Sandy Koufax after the 1966 season highlighted many roster changes and the team dipped in the National League standings.

BANISHED TO BUCS. Maury Wills's first tenure with the Dodgers ended weeks after he left the ball club during its Japan tour following the 1966 season, citing a sore knee. Wills, photographed in Hawaii playing a banjo on stage in a nightclub, was dealt to the Pittsburgh Pirates. The following spring, Wills chats with Dodger newcomer Dick Stuart. The Dodgers later re-acquired Wills in 1969 and he spent his final four seasons in a Los Angeles uniform.

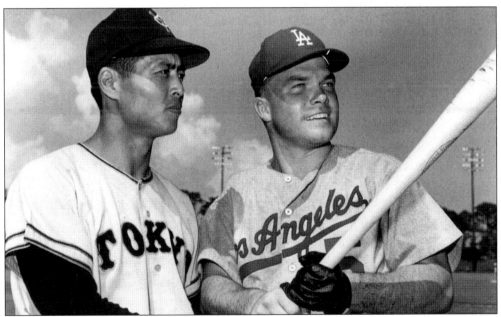

INTERNATIONAL EXCHANGE. The Dodgers toured Japan following the 1966 season and invited the Tokyo Giants to their spring training headquarters in 1967. Jim Lefebvre, the 1965 National League Rookie of the Year who hit a career-high 24 home runs in 1966, visits Sadaharu Oh, who hit 868 lifetime home runs with the Giants from 1959 to 1982.

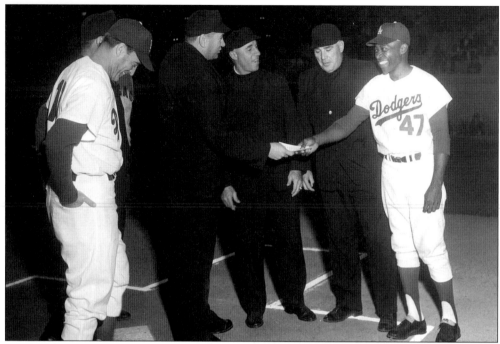

SANDY RETURNS. It wasn't Koufax, though. Former outfielder and 1955 World Series hero Sandy Amoros carries the lineup card prior to the Dodgers' home game against the Chicago Cubs on May 12, 1967. His active career ended with the Detroit Tigers in 1960, but the Dodgers carried the 37-year-old Amoros on the roster so he could qualify for the major league pension.

GOOD NEWS. The *Pasadena Star-News* printed special editions for a pre-season baseball clinic featuring pitcher Jim "Mudcat" Grant and outfielder Al Ferrara. The 1968 Dodgers, though, finished tied for seventh. The biggest highlight of the season was Don Drysdale's streak of 58²/₃ consecutive scoreless innings.

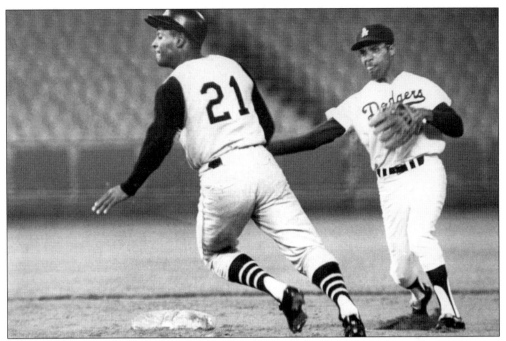

ROLLING THE DICE. The Dodgers acquired shortstop Zoilo Versailles prior to the 1968 season with hope that the former Minnesota Twins' shortstop would regain the form that earned him American League MVP honors in 1965. Versailles hit .393 during the spring, but hurt his back and batted just .196 in 110 games during the regular season. Against the Pirates on April 15, Versalles turns a double play in front of the Robert Clemente.

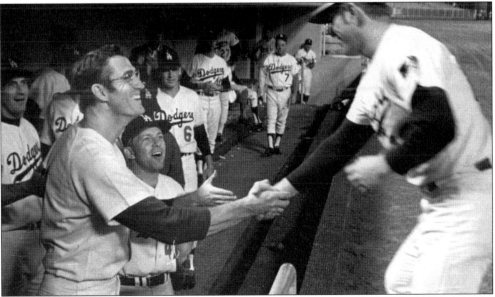

HOME RUN. Andy Kosco heads the dugout reception for rookie third baseman Bill Sudakis, who hit a home run against the Pittsburgh Pirates on August 6, 1969. Such events were rare for the 1968 Dodgers, who hit Los Angeles franchise-low 67 home runs as a team. Len Gabrielson (10) was the only hitter to reach double-digits. The 1969 Dodgers improved to 97 home runs, led by Kosco (19).

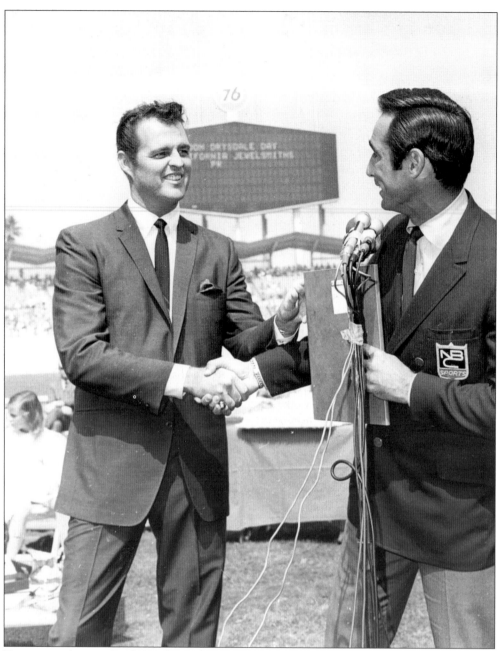

TOGETHER AGAIN. Sandy Koufax and Don Drysdale were the greatest pitching duo in Dodger history, winning a combined 338 games as teammates from 1956 to 1966. Like Koufax, Drysdale's Hall of Fame career was cut short by injuries and he retired at age 33 in 1969. On "Don Drysdale Day," Big D receives good wishes from Koufax, wearing his NBC broadcasting blazer. Although Koufax eventually left his network life in front of the cameras, Drysdale became a broadcaster for the Expos, Angels, White Sox, and Dodgers.

FOUR
The 1970s

After 20 years as team president, Walter O'Malley became chairman of the board on March 17, 1970 and handed the reigns to his son Peter, who worked at various levels of the Dodger organization. Peter O'Malley began working full-time for the Dodgers in 1962 as director of the club's Dodgertown spring training headquarters in Vero Beach, Florida. He became president of the Triple-A Spokane affiliate in 1965 and returned to Los Angeles in 1967 as vice president in charge of stadium operations.

The younger O'Malley accompanied the Dodgers on their goodwill tour of Japan in 1956, and the reception given to the Brooklyn ball club made a lasting impression, including an outfield scene in which Gil Hodges overcame the language barrier by pantomiming to the crowd.

The early 1970s marked a transition for the Dodger roster in terms of its younger players. Veterans such as Maury Wills—who returned to Los Angeles in 1969 after his "exile" to the Pittsburgh Pirates in 1967—Wes Parker, and Jim Lefebvre were gone after the 1972 season. The era also marked the one-year Dodger careers of two famous sluggers, Dick Allen (1971) and Frank Robinson (1972).

An amateur draft in 1968 gave the Dodgers a bonanza of future major leaguers, including Steve Garvey, Ron Cey, Joe Ferguson, Charlie Hough, Bill Buckner, Tom Paciorek, and Steve Yeager. And managing many of those prospects in the minor leagues was Tommy Lasorda, the motivational master who instructed his players to write letters to the big-league Dodgers and announced that one day they would take over their jobs. Lasorda, too, was on a fast track to the major leagues and he joined Manager Walter Alston's staff in 1973.

Outfielder Willie Davis, who established numerous Los Angeles career records, spent his final season in a Dodger uniform in 1973 and was later traded to Montreal in a major deal for Montreal relief pitcher Mike Marshall. Another off-season trade brought outfielder Jimmy Wynn to Los Angeles in exchange for pitcher Claude Osteen. Marshall and Wynn paid off instantly as the Dodgers won the pennant in 1974.

General Manager Al Campanis pulled off other successful transactions during a decade that brought free agency to the industry, which began in part when Dodger pitcher Andy Messersmith wanted a no-trade clause in his 1975 contract. Such a request was against club

policy and the Dodgers renewed his contract. Messersmith refused to sign the document and an arbitrator ruling on a Players Association grievance that winter declared that Messersmith and Montreal's Dave McNally were free agents, striking down baseball's reserve system.

Unlike other teams, the Dodgers didn't make a splash in the early free agent bidding wars and Campanis instead opted for trades. From 1975 to 1979, Campanis acquired pitcher Burt Hooton (Cubs), outfielder Dusty Baker (Braves), Rick Monday (Cubs), outfielder Reggie Smith (Cardinals) and pitcher Jerry Reuss (Pirates) along with other key veterans who blended with the organization's home-grown talent.

When Alston retired as Dodger manager on September 27, 1976, it ended a remarkable run in which the Ohio native signed a series of one-year contracts for 23 seasons. His predecessor, Charlie Dressen, lost his job following a 1953 World Series appearance when he demanded a multi-year contract. O'Malley called his bluff and hired Alston, who won 2,040 regular season games and four World Series titles.

Lasorda took over as the Dodger manager and his claims of "bleeding Dodger blue" would become synonymous with the organization, along with his on-field theatrics with umpires. For his first workout against the University of Southern California at Dodger Stadium in February 1977, the bases were painted blue and a fresh coat of blue paint was added to the outfield wall.

The marketing campaign took off. The mixture of Lasorda's showmanship and a quality product on the field gave fans a chance to cheer an exciting "Big Blue Wrecking Crew," a takeoff on the National League West rival Cincinnati Reds' "Big Red Machine" nickname. On the field, Steve Garvey, Dusty Baker, Ron Cey, and Reggie Smith became members of a "30 Home Run Club," the first quartet to hit at least 30 home runs each for the same team in one season. And the Dodger infield of Garvey, Davey Lopes, Bill Russell, and Cey was in the middle of an 8^1/$_2$-year tenure from 1973 to 1981, the longest in major league history. Don Sutton anchored a pitching staff that featured starters Tommy John, Hooton, Doug Rau, and Rick Rhoden.

The Dodgers opened the 1977 season with a 17-3 record and attendance soared with the excitement of a pennant contender. The Dodgers drew 2.9 million fans in 1977 and in 1978 became the first team in major league history to surpass the 3 million mark. Overall, 3,347,845 fans attended Dodger Stadium in 80 dates, which included a scheduled Saturday afternoon doubleheader with the New York Mets on September 2 that drew 49,818.

Lasorda joined Gabby Street (Cardinals, 1930–1931) as the only National League managers in history to capture consecutive pennants in his first two seasons. But the World Series losses against the New York Yankees in 1977 and 1978 left a group of veterans unfulfilled and frustrated. In their first encounter of the decade, New York's Reggie Jackson became "Mr. October" with three consecutive home runs in the sixth and final game at Yankee Stadium. In the 1978 rematch, the Dodges captured the first two games in Los Angeles, Game 2 saved when rookie Bob Welch struck out Jackson for the game's final out. But New York won the next four games, including a key 4-3 victory in ten innings in Game 4 at Yankee Stadium.

Los Angeles stumbled to a third-place finish in 1979, and the Dodger veterans who began the 1970s as blue-chip prospects wondered at the end of the decade whether they would get a chance at another championship.

NEW LEADERSHIP. Peter O'Malley (right) succeeded his father, Walter, as Dodger president on March 17, 1970. With O'Malley in spring training is Al Campanis, the former Brooklyn infielder and Los Angeles scouting director who became general manager in 1969 following the resignation of Buzzie Bavasi and the death of Fresco Thompson. Bavasi became general manager of the expansion San Diego Padres.

GOING FISHING. Taking a break at spring training are, from left to right, pitchers Jim Brewer, Don Sutton, and Claude Osteen. Sutton and Osteen combined for 31 victories in 1970, and Brewer anchored the bullpen with a career-high 24 saves as the Dodgers finished second in the National League West behind Cincinnati.

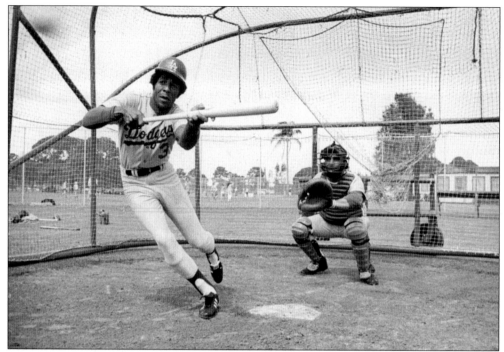

WILLIE DAVIS. The outfielder played with the Dodgers from 1960 to 1973 and set many all-time Los Angeles career marks, including most hits (2,091), at-bats (7,495), runs (1,004), and total bases (3,094). He authored a 31-game hitting streak in 1969 and led the National League with 16 triples in 1970.

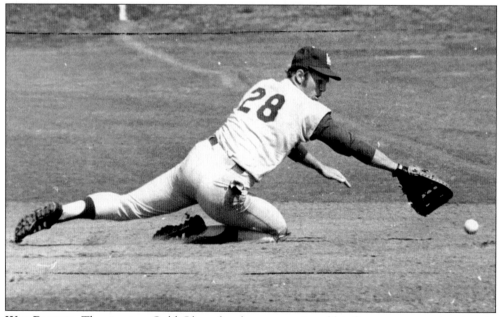

WES PARKER. The six-time Gold Glove first baseman enjoyed his finest season at the plate in 1970, batting .310 with 10 home runs, 47 doubles, and 111 RBI. Parker played two more seasons with the Dodgers and retired in 1972 at age 32.

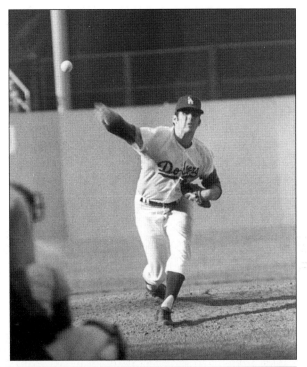

SINGER THROWING MACHINE. Bill Singer notched his only career no-hitter against the Philadelphia Phillies on July 20, 1970. The game began at 4 p.m. and ended in the twilight as pinch-hitter Byron Browne fouled out to catcher Jeff Torborg to end the game. It would be the only no-hitter by a right-handed pitcher in the first 30 years of Dodger Stadium.

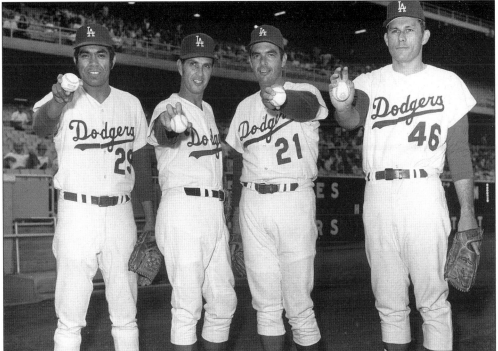

RELIEF CORPS. The Dodgers' 1971 bullpen included members with trademark pitches. From left to right are Jose Pena (forkball), Hoyt Wilhelm (knuckleball), Jim Brewer (screwball), and Pete Mikkelsen (palmball). The committee combined for 31 saves as the second-place Dodgers finished one game behind San Francisco in the National League West.

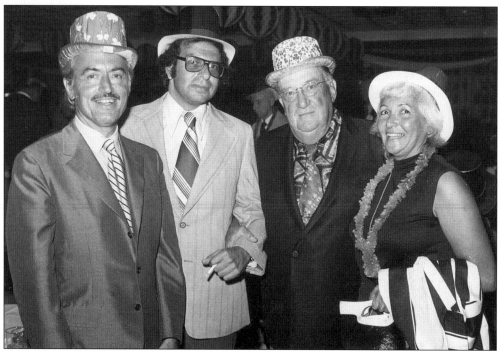

LABOR TALKS. Despite an impending players' strike, union leader Marvin Miller, left, and his wife, Terry, visited Dodgertown in 1972 and attended Walter O'Malley's annual St. Patrick's Day party. Also pictured is Players Association attorney Richard Moss.

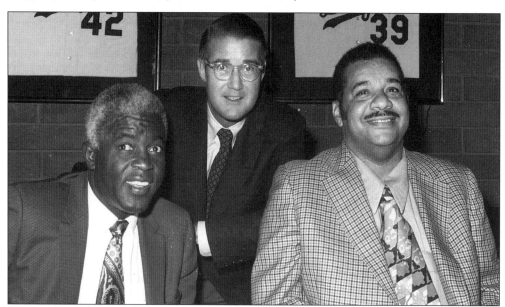

RETIRED NUMBERS. During Oldtimers Day weekend festivities in 1972, the Dodgers retired the first three uniform numbers in their history belonging to Hall of Famers Jackie Robinson (42), Roy Campanella (39), and Sandy Koufax (32). Dodger president Peter O'Malley poses at the luncheon with Robinson and Campanella. It would be the final Dodger Stadium appearance for Robinson, who passed away in October 1972 at the age of 53.

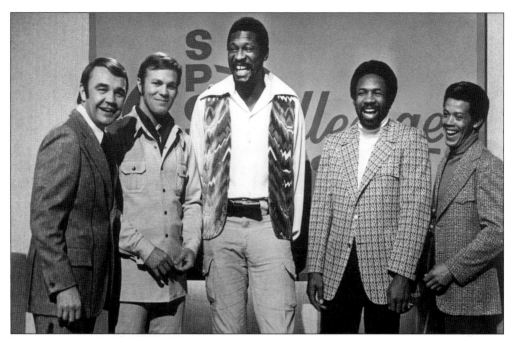

SPORTS CHALLENGE. Members of the 1972 Dodgers appeared on the sports trivia television show, along with a basketball legend who shared the same name as the Los Angeles shortstop. Pictured, from left to right, are host Dick Enberg, first baseman Wes Parker, the "other" Bill Russell, Frank Robinson, and Maury Wills.

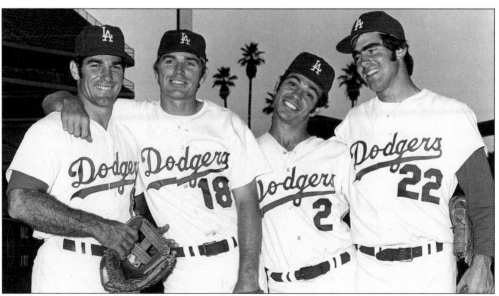

NEW BLOOD. The transition from veterans to rookies began in the early 1970s with a new crop of infielders, including, from left to right, Steve Garvey, Bill Russell, Bobby Valentine, and Bill Buckner. Garvey began his career as a scatter-armed third baseman. Russell was a converted outfielder who found a home at shortstop. Valentine played second base, third base, shortstop, and the outfield for the Dodgers in 1972, but was traded to the Angels. Buckner moved to left field after Garvey was switched to first base in the middle of the 1973 season.

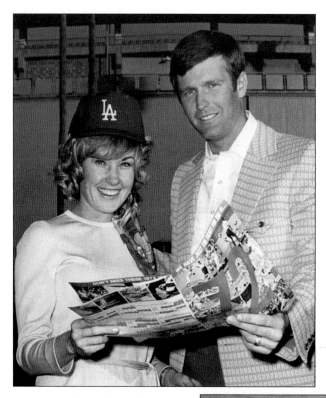

TOMMY JOHN. Acquired from the Chicago White Sox prior to the 1972 season in exchange for Dick Allen, Tommy John poses with his wife, Sally, on his first visit to Dodger Stadium. John made medical history in 1976 when he returned from tendon transplant surgery. The procedure on his left elbow was named "Tommy John surgery" by Dodger physician Dr. Frank Jobe. John won 288 games during his 26-year career in the majors from 1963 to 1989.

MIGHTY CASEY. The Dodgers held their first Oldtimers Day in 1971 and former player and Manager Casey Stengel was the center attraction at many of the early reunions. This 1972 picture captures Stengel's reaction to longtime umpire Beans Reardon in the clubhouse prior to the game. Stengel played for the Brooklyn Dodgers from 1912 to 1917 and managed them from 1934 to 1936.

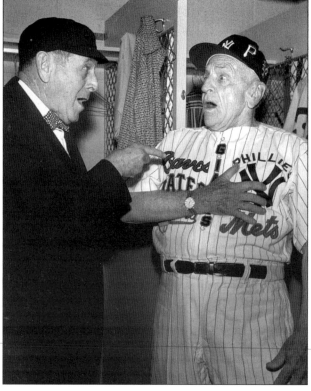

ANDY MESSERSMITH. Acquired from the California Angels prior to the 1973 season, right-hander Andy Messersmith teamed with Don Sutton to give the Dodgers a 1-2 starting punch in their quest to dethrone the Cincinnati Reds in the National League West. Messersmith went 20-6 in 1974 as Los Angeles won the division flag by four games over the Reds.

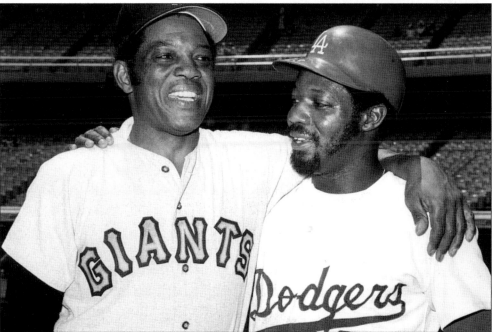

THE TOY CANNON. Outfielder Jimmy Wynn became the Dodgers' offensive catalyst during their pennant-winning season in 1974. Acquired from the Houston Astros in a trade for pitcher Claude Osteen, Wynn clouted 32 home runs and drove in 108 runs. Wynn poses with Willie Mays, the retired San Francisco Giants' star who wore uniform No. 24 as did Wynn while becoming Houston's all-time home run leader.

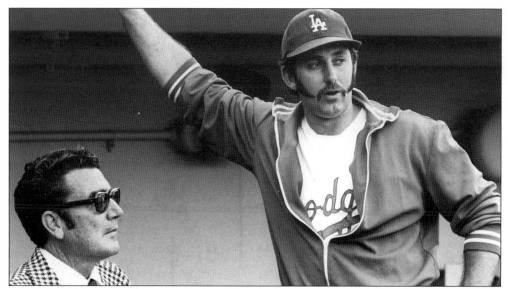

IRON MIKE. Mike Marshall, pictured with *Los Angeles Times* sports columnist Jim Murray, became the first reliever to win Cy Young Award honors in 1974. While posting a 15-12 record, a 2.42 ERA, and 21 saves, Marshall set single-season marks for relief pitchers with 106 appearances and 208 innings. By comparison, Eric Gagne pitched 82.1 innings in 77 games en route to 55 saves during his Cy Young Award season in 2003.

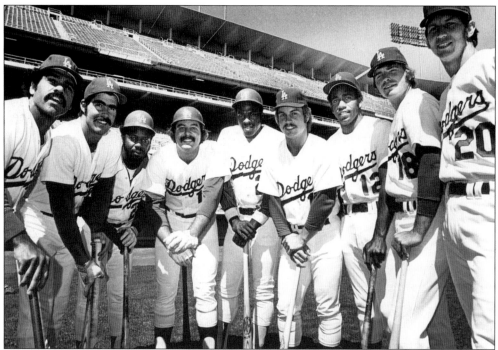

OPENING DAY 1974. The Dodgers' lineup included, from left to right, second baseman Davey Lopes, first baseman Bill Buckner, center fielder Jimmy Wynn, catcher Joe Ferguson, right fielder Willie Crawford, third baseman Ron Cey, left fielder Von Joshua, shortstop Bill Russell, and pitcher Don Sutton. The Dodgers went 102-60 and made the playoffs for the first time since 1966.

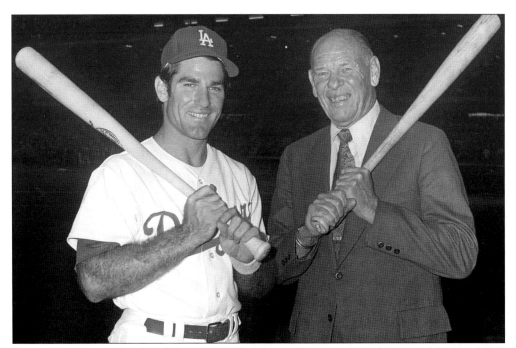

STEVE GARVEY. In his first full season at first base, Garvey garnered National League MVP honors, batting .312 in 156 games with 21 home runs and 111 RBI. Garvey, pictured with former Brooklyn Dodger outfielder Babe Herman, didn't appear on the All-Star Game ballot, but he was elected to the starting lineup by the fans as a write-in candidate.

1974 WORLD SERIES. The first Fall Classic featuring two West Coast teams opened at Dodger Stadium and Los Angeles captured its only victory behind the pitching of Don Sutton and Mike Marshall in Game 2. Four of the five contests were decided by scores of 3-2 as Oakland won its third consecutive championship.

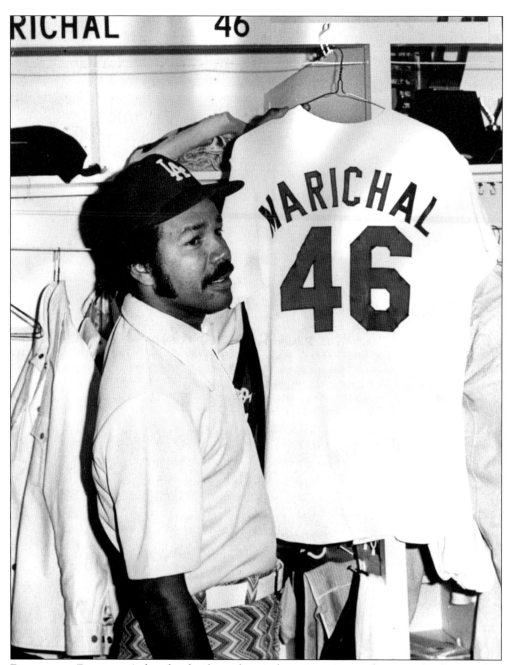

RETIRING A DODGER. A decade after his infamous bat-swinging attack against Dodger catcher John Roseboro, pitcher Juan Marichal ended his Hall of Fame career in a Los Angeles uniform. Marichal joined the Dodgers at age 37 in 1975, but he retired after making two relief appearances in early April. Marichal and Roseboro eventually became friends and Marichal was one of the speaker's at Roseboro's funeral in 2002.

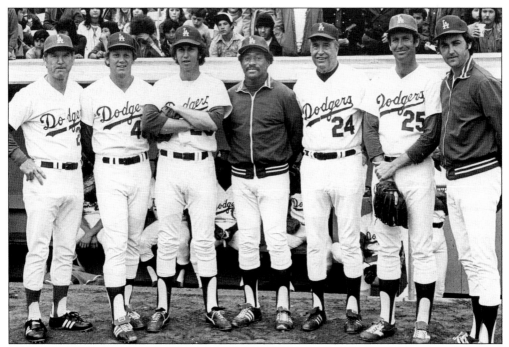

ALSTON'S FINAL STAFF. In his final season as Dodger manager, Walter Alston's pitching staff posted a 3.02 ERA, which ranked second in the league behind the New York Mets (2.94). The 1976 squad included, from left to right, pitching coach Red Adams, Burt Hooton, Don Sutton, Al Downing, Alston, Tommy John, and Doug Rau.

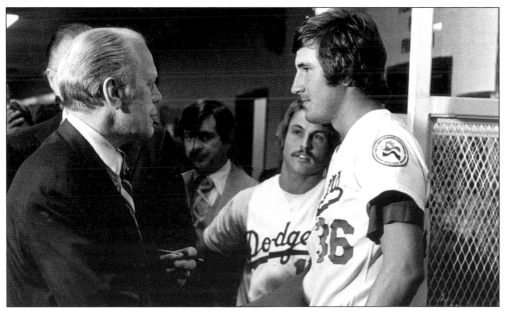

ALL-STAR SURPRISE. The only Dodger pitcher selected to the National League All-Star team in 1976 was rookie right-hander Rick Rhoden, who began the season with a 9-0 record. Rhoden met President Gerald Ford in the All-Star clubhouse and was on the mound for Walter Alston's 2,000th career victory as Dodger manager on July 17.

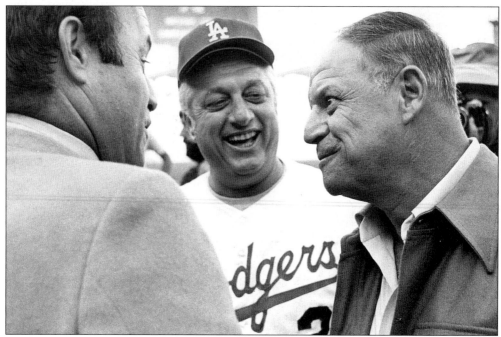

TOMMY LASORDA. There was a new spirit in the Dodger dugout when Tommy Lasorda began his first full season with Los Angeles in 1977. Hollywood stars visited his office and Lasorda's enthusiastic claims of "bleeding Dodger blue" were a sharp contrast to his low-key predecessor, Walter Alston. In this photo, Lasorda shares a laugh with sportscaster Joe Garagiola and comedian Don Rickles.

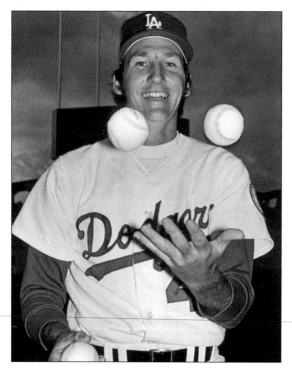

CHARLIE HOUGH. The right-hander pitched for the Dodgers from 1970 to 1980 and compiled 60 saves. Converted to a full-time starter in the American League, the knuckleball artist returned to the National League with the Florida Marlins at age 45 in 1993 and defeated the Dodgers in the franchise's first game.

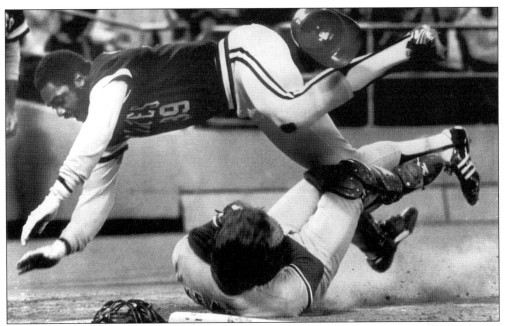

CRASH COURSE. On August 25, 1977, a home-plate collision with Pittsburgh's Dave Parker knocked catcher Steve Yeager out of the game. "I think Yeager would have a better chance with a pickup truck," said Manager Tommy Lasorda. Yeager held onto the ball and was not seriously injured, but was knocked out of the starting lineup for a week.

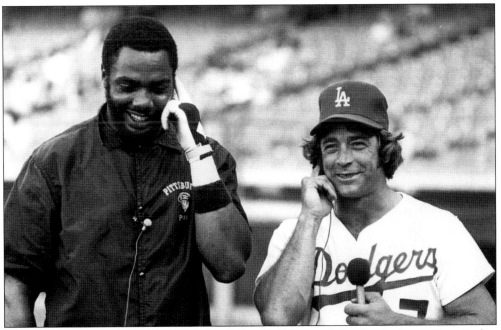

ACCIDENT REPORT. Back in Los Angeles, 6-foot-5, 250-pound Pittsburgh slugger Dave Parker and 6-0, 190-pound Steve Yeager recall their home-plate collision weeks earlier at Three Rivers Stadium during a television interview at Dodger Stadium. Yeager batted .256 in 125 games and threw out 34 of 86 base stealers for the pennant-winning Dodgers in 1977.

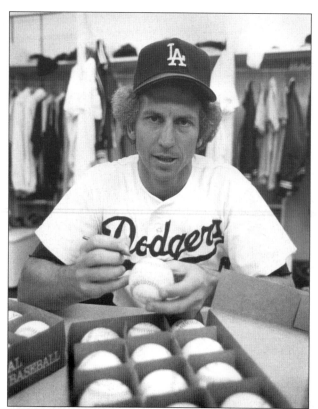

DON SUTTON. The right-hander set all-time Los Angeles standards for most victories (233), starts (533), strikeouts (2,696), innings (3,814), and shutouts (52). Sutton won a career-high 21 games in 1976 and was the MVP of the 1977 All-Star Game at Yankee Stadium. During a 4-3 victory over the Cincinnati Reds on June 23, 1978, Sutton struck out his 2,283rd career batter to tie Don Drysdale's Los Angeles record. The next day, Sutton wrote the details on the baseball in the clubhouse.

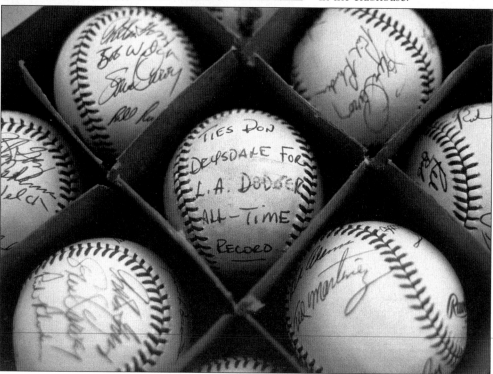

GREAT SUPPORT. In 1978, the Dodgers became the first major league team to draw more than 3 million fans as they established a record total of 3,347,845 in 80 dates, which included a doubleheader against the Mets at home on September 2.

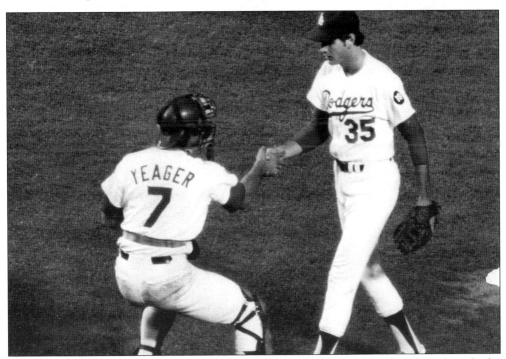

FEARLESS ROOKIE. Pitcher Bob Welch and New York Yankees' slugger Reggie Jackson had a classic confrontation in the second game of the 1978 World Series. After Jackson fouled off three consecutive full-count pitches, Welch struck out "Mr. October" to preserve the Dodgers' 4-3 win. The Yankees, though, captured the Series in six games.

75

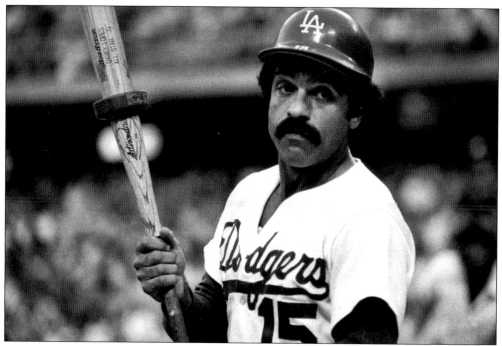

POWER SURGE. Davey Lopes was known as the Dodgers' leadoff hitter and stolen-base artist during his tenure with Los Angeles from 1972 to 1981. But in 1979, Lopes belted a career-high 28 home runs, including 20 prior to the All-Star break. Lopes finished with 155 home runs in 6,354 career at-bats in the majors through 1987.

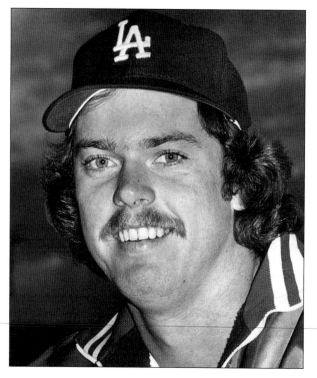

ROOKIE SUCCESS. Rick Sutcliffe made the Dodger roster in 1979 as the long man in the bullpen. But when Burt Hooton missed his May 3 start because of the flu, Sutcliffe pitched a complete game against the Phillies at Dodger Stadium and stayed in the starting rotation. He went 17-10 with a 3.46 ERA and won National League Rookie of the Year honors.

FIVE

The 1980s

The decade began with excitement as Dodger Stadium hosted its only All-Star Game in 1980. In addition to the pageantry associated with the game and civic functions, the ballpark received its first major facelift with a state-of-the-art Dodger Diamond Vision, the largest matrix board in the world. Replacing the original message board above the Left Field Pavilion, the system worked on the same principal as a home color TV set. The Diamond Vision was built in Japan by Mitsubishi and made its debut at the July 8 Mid-Summer Classic, won by the National League, 4-2. Dodger All-Stars included first baseman Steve Garvey, second baseman Davey Lopes, shortstop Bill Russell, outfielder Reggie Smith, and pitchers Bob Welch and Jerry Reuss.

The 1980 season featured the emergence of the Houston Astros, competing for their first National League West title and postseason appearance since joining the league in 1962. The Astros lost their ace pitcher, J.R. Richard, to a stroke in the middle of the season. But the pitching of Joe Niekro, Vern Ruhle, Ken Forsch, and free agent–acquisition Nolan Ryan kept the Astros in an exciting race with a Los Angeles staff led by Reuss, who went from 7-14 in 1979 to 18-6 in his second season with the Dodgers. The Dodgers trailed by three games going into the final weekend of the season at Dodger Stadium. Needing a sweep to force a one-game playoff, the Dodgers staged three consecutive one-run victories that produced lasting images. Joe Ferguson kicked off the weekend with a 10th-inning home run on October 3, flipping his batting helmet toward the dugout as he rounded third base and picking up his manager at home plate. The Sunday afternoon game included a seventh-inning home run by Ron Cey, who moments earlier fouled a pitch off his foot causing him tremendous pain as he rounded the bases. Don Sutton emerged from the bullpen and pitched two innings to save the 4-3 decision.

But the Dodgers ran out of pitching and were forced to start Dave Goltz, a free-agent import from the Minnesota Twins who struggled to a 7-11 record in his first season with Los Angeles, in the one-game playoff at Dodger Stadium on October 6. Cey wasn't available for the game because of the injured foot, and Houston's Joe Niekro defeated Goltz, 7-1.

The Astros returned for Opening Day in 1981, beginning a remarkable chapter in Dodger history. Sutton had left the Dodger staff and joined Houston via free agency. Injuries to Reuss and Burt Hooton prompted Lasorda to give the starting assignment to a 20-year-old rookie.

Although he went 2-0 with 18 scoreless innings after his September 1980 promotion, there was still a degree of mystery when Fernando Valenzuela took the mound for his first major league start. Hours later, a legend was born when the Mexico native pitched a 2-0 complete-game victory. Los Angeles soon was caught in the grips of "Fernandomania" when Valenzuela started the season with an 8-0 mark and 0.50 ERA with five shutouts.

The major league players' strike shut down the season on June 11, which might have given Valenzuela a chance to rest his arm following a 1-4 record after May 15. When the 50-day strike was settled in August, the Dodgers were declared champions of "the first half" by virtue of a one-half game lead in the National League West. When the "second half" resumed on August 10, the Dodgers were in the position of knowing they had already qualified for the playoffs. The awkward circumstances leading to the postseason would be erased over time, thanks to memorable playoff series with the Astros and Expos. Houston won the first two games of a best-of-five Division Series format, but the Dodgers roared back as they had in 1980. Another three-game winning streak was good enough to eliminate the Astros. The five-game Montreal series was highlighted by Rick Monday's ninth-inning home run off Steve Rogers in Game 5, which gave Los Angeles and Valenzuela a 2-1 victory.

In the World Series, the veterans finally won their championship, but it wasn't easy. They lost the first two games at Yankee Stadium and watched Valenzuela struggle through a dramatic 5-4 victory in Game 3. Jay Johnstone's pinch-hit home run in Game 4 helped the Dodgers overcome a 6-3 deficit and was the turning point in the Series, which they closed out with a 9-2 victory in Game 6 at Yankee Stadium.

Just when the Dodgers appeared poised for another title run, they lost the division to Atlanta by one game in 1982 when San Francisco's Joe Morgan hit a game-winning home run off Dodger reliever Terry Forster on the final day of the regular season at Candlestick Park.

By 1983, shortstop Bill Russell was the lone holdover from the longest tenured infield group in history. Steve Garvey had been replaced at first base by left-handed slugger Greg Brock, Steve Sax took the second-base duties from Davey Lopes, and a variety of candidates starting with converted outfielder Pedro Guerrero attempted to fill Cey's shoes at third base. The Dodgers won division titles in 1983 and 1985, but failed to advance past the League Championship Series.

The Dodgers stumbled to consecutive 73-89 records in 1986 and 1987, their first consecutive losing seasons since the post–Sandy Koufax departure gloom of 1967 and 1968. But their fortunes turned around in 1988 when General Manager Fred Claire signed free-agent outfielder Kirk Gibson, whose fiery leadership brought together a team effort, and the Cy Young Award efforts of 23-game winner Orel Hershiser led the Dodgers into the playoffs. Those two men played key roles in October. Gibson's World Series home run as a pinch-hitter in Game 1 became the city's most memorable sports moment and Hershiser earned Series MVP honors, capping a season in which he authored a record 59 scoreless innings to surpass the mark set in 1968 by Dodger pitcher Don Drysdale, who returned to Los Angeles in 1988 as a broadcaster.

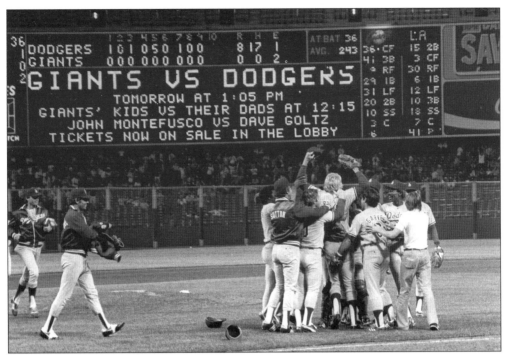

JERRY REUSS. The left-hander went 7-14 in his first season with the Dodgers in 1979, but he rebounded with an 18-6 mark in 1980 and led the league with six shutouts. Reuss pitched his only career no-hitter on April 27 at San Francisco and finished second to Steve Carlton in the National League Cy Young Award balloting.

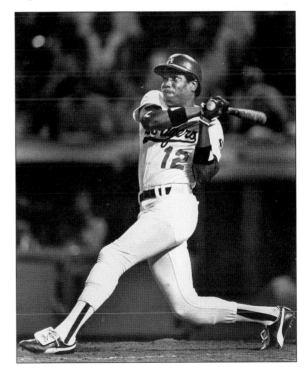

DUSTY BAKER. The outfielder played with Los Angeles from 1976 to 1984 and was part of the major league's first 30–home run quartet in 1977 with teammates Steve Garvey, Ron Cey, and Reggie Smith. He later became a prolific manager and guided the Giants to the World Series in 2002 and the Cubs to the League Championship Series in 2003.

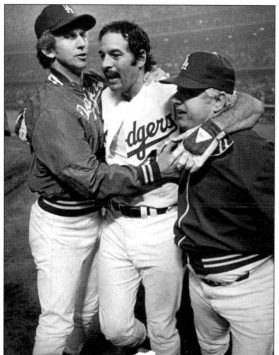

THE SWEEP. Needing to win their final three games of the regular season to tie the Astros, Joe Ferguson triggered a wild weekend with a 10th inning home run on October 3 to give the Dodgers a 3-2 victory. Ferguson wildly raced around the basepaths and celebrated by the dugout with pitcher Don Sutton and Manager Tommy Lasorda.

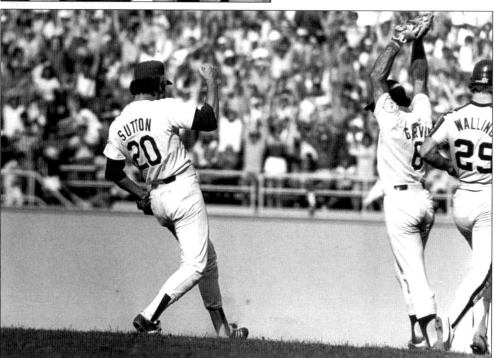

THE FINAL OUT. Don Sutton came out of the bullpen on the final day of the regular season in 1980 to preserve a 4-3 victory over Houston, which forced a one-game divisional playoff. The Dodgers would lose the playoff game and Sutton, a Dodger since 1966, would leave Los Angeles via free agency and sign with Houston.

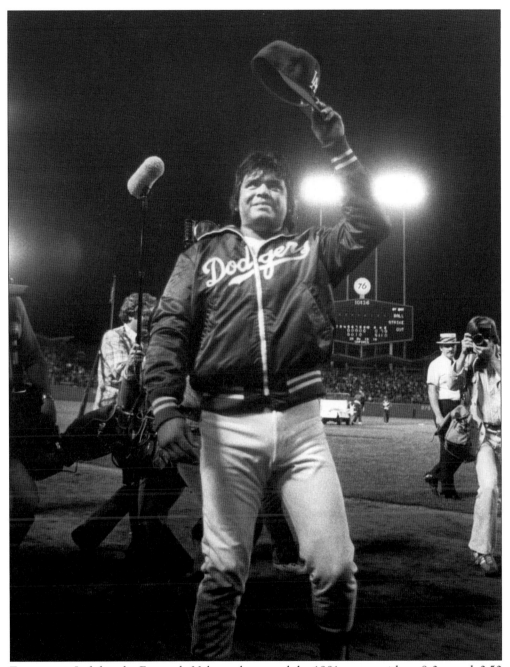

FERNANDO. Left-hander Fernando Valenzuela opened the 1981 season with an 8-0 record, 0.50 ERA, and five shutouts, triggering "Fernandomania" as the Mexico native became an international celebrity. Valenzuela finished with a 13-7 mark and became the only player to win both the Rookie of the Year and Cy Young Awards in the same season.

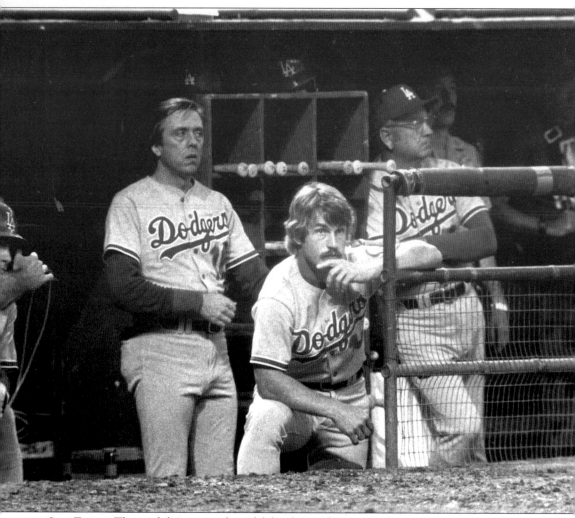

SAD FACES. Things didn't appear hopeful for the Dodgers in Houston when they lost the first two games of the Division Series at the Astrodome, the second by a 1-0 margin in 11 innings. But Los Angeles rallied with three consecutive victories at Dodger Stadium, including a 4-0 decision in the deciding Game 5 as Jerry Reuss outlasted Nolan Ryan.

MONTREAL PARTY. The Expos were in a good mood during the 1981 National League Championship Series, taking a 2-1 lead entering Game 4 at Montreal. Youpii, the Expos' mascot, has fun in the box seats with Dodger president Peter O'Malley. The Expos were looking for their first World Series appearance since joining the league in 1969.

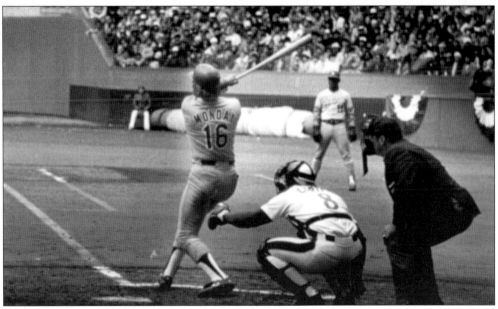

DRAMATIC COMEBACK. In the 1981 National League Championship Series, the Dodgers held off elimination at Montreal with a 7-1 victory in Game 4. The deciding fifth game was a 1-1 deadlock in the ninth inning until Rick Monday's home run off relief pitcher Steve Rogers. The 2-1 victory gave the Dodgers a World Series berth against the New York Yankees.

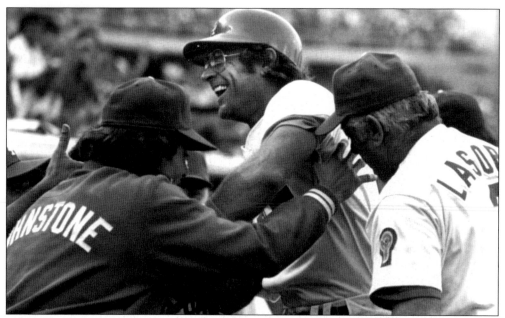

1981 WORLD SERIES. The Dodgers lost the first two games at Yankee Stadium, but won the next four to capture their fourth championship in Los Angeles and first since 1965. Pedro Guerrero and Steve Yeager (pictured) hit consecutive home runs in the seventh inning off left-hander Ron Guidry in Game 5 at Dodger Stadium to give Los Angeles a 2-1 victory and 3-2 Series lead.

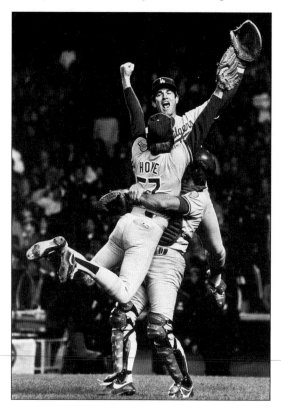

THE CHAMPS. Bob Watson's flyout to center fielder Ken Landreaux ended the 1981 World Series at Yankee Stadium and started a celebration near home plate with pitcher Steve Howe, first baseman Steve Garvey, and catcher Steve Yeager. The Dodgers clinched the title with a 9-2 victory as Yeager, Pedro Guerrero, and Ron Cey were named tri-Most Valuable Players of the Series.

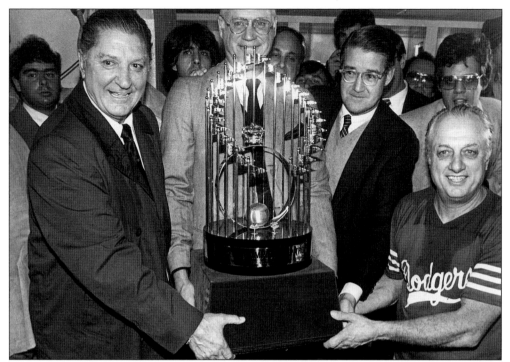

TROPHY TIME. In the victorious Dodger clubhouse, the World Series trophy is presented to the team that staged postseason comebacks against the Astros, Expos, and Yankees. From left to right are General Manager Al Campanis, baseball commissioner Bowie Kuhn, team president Peter O'Malley, and Manager Tommy Lasorda.

NAME THAT TUNE. Manager Tommy Lasorda celebrates on the guitar when his pitcher, Fernando Valenzuela, is named the winner of the National League Cy Young Award. In addition to his 13-7 record during the regular season, Valenzuela was the winning pitcher in the deciding Game 5 of the League Championship Series at Montreal and World Series Game 3 at Los Angeles against the Yankees.

BLUE BROTHERS. Second baseman Steve Sax leaps over his brother Dave during spring training in 1982. Steve Sax won National League Rookie of the Year honors that season and set a Dodger rookie record with 49 stolen bases. Dave Sax, a reserve catcher, appeared in nine games overall with Los Angeles in 1982–1983.

GOODBYE GARV. The 1982 season was the final one in a Dodger uniform for Steve Garvey, the All-Star and Gold Glove first baseman who set a club record with 1,107 consecutive games, a streak that began on September 3, 1975. The streak eventually became the National League standard at 1,207 games when he extended it with the San Diego Padres in 1983.

YOUNG TALENT. Among the pitchers and catchers reporting to spring training in 1983 were some soon-to-be familiar faces: (from left to right) Dave Sax, Steve Howe, Ricky Wright, Mike Scioscia, Larry White, Paul Voight, and Orel Hershiser. Howe led the club with 18 saves in 1983, but he missed the playoffs due to a suspension for his involvement with illegal drugs. Hershiser made his major league debut on September 1 and posted a 3.38 ERA in eight relief appearances.

COMEBACK TRAIL. Catcher Mike Scioscia worked hard during the spring in 1983 to improve his physical condition, but he appeared in just 12 games for the Dodgers that season. Scioscia's season ended prematurely on May 14 in San Diego when he suffered a slight tear in his rotator cuff in his right shoulder while throwing out Alan Wiggins attempting to steal second base. He spent the rest of the season rehabilitating his shoulder and serving as the team's "Eye in the Sky" scout in the press box.

PEDRO GUERRERO. With the departure of Ron Cey, the Dodgers switched Pedro Guerrero from right field to third base in 1983. Guerrero responded with a banner season—a .298 batting average with 32 home runs and 103 RBI in 160 games. Guerrero returned to the outfield during the 1984 season.

GREG BROCK. The heralded rookie first baseman faced the challenge of replacing Dodger legend Steve Garvey after his departure to San Diego via free agency after the 1982 season. Brock batted .224 in 146 games in 1983 with 20 home runs and 66 RBI. He stayed with Los Angeles through the 1986 season.

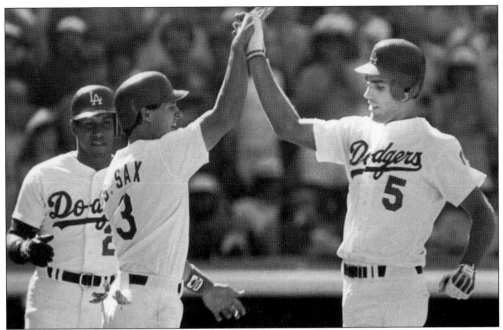

MIKE MARSHALL. The outfielder joined Greg Brock as a rookie to watch in 1983. Marshall took over right-field duties from Pedro Guerrero in 1983 and batted .284 in 140 games with 17 home runs and 65 RBI. He also helped the Dodgers capture the National League West title as he ranked second on the team in batting average and had 11 game-winning RBI.

ST. PATRICK'S DAY. This tradition was started by Dodger president Walter O'Malley and continued with his son Peter. Attending this March 17 party in Vero Beach are, from left to right, Joyce Schweppe, Hall of Fame pitcher Sandy Koufax, executive vice president Fred Claire, and minor league vice president Bill Schweppe.

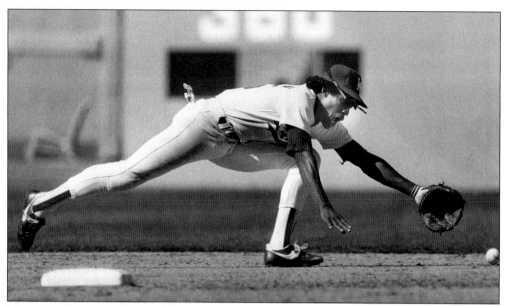

MARIANO DUNCAN. Ticketed for Triple-A Albuquerque, Mariano Duncan found himself in the Opening Day lineup at second base in 1985 after injuries to Steve Sax and Bob Bailor. Duncan later became the team's starting shortstop on June 1 after an injury to Dave Anderson. Duncan batted .244 in 142 games.

VETERAN HURLERS. In 1985, pitchers Fernando Valenzuela, Jerry Reuss, and Rick Honeycutt combined for 39 victories as the Dodgers captured the National League West title by 5½ games over Cincinnati. The ace of the staff was Orel Hershiser, who in his second full season went 19-3 with a 2.03 ERA and five shutouts.

ELIMINATED. Manager Tommy Lasorda discusses the end of the Dodgers' playoff hopes in 1985 following Game 6 of the League Championship Series at Dodger Stadium. Jack Clark's two-out, three-run home run in the ninth inning gave St. Louis a 7-5 victory and a World Series berth. Pitcher Tom Niedenfuer, who entered the game in the seventh inning in relief of Orel Hershiser, faced Clark with first base open and Andy Van Slyke on deck. Lasorda didn't have the luxury of a left-handed closer after Steve Howe was placed on baseball's restricted list on June 30.

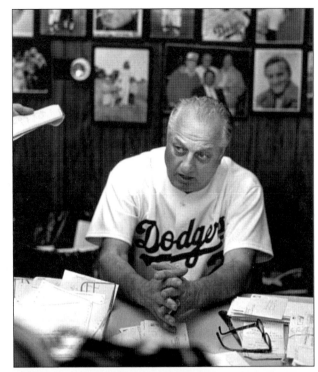

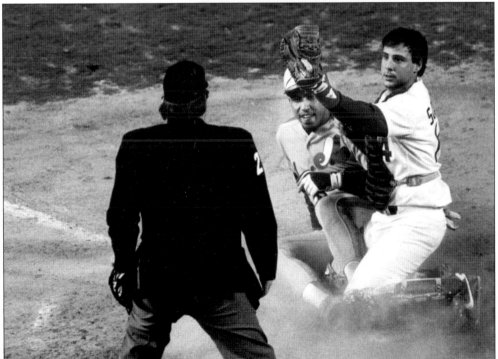

BLUE PLATE SPECIAL. Mike Scioscia appeared in a career-high 142 games with Los Angeles in 1987. The plate-blocking specialist would establish a Dodger record for most games by a Los Angeles catcher (1,395) from 1980 to 1992.

THE STREAK. Orel Hershiser pitched 59 consecutive scoreless innings to close out his Cy Young Award season in 1988. Hershiser surpassed the previous mark of 58²/₃ innings established by Dodger Don Drysdale in 1968. Drysdale was a Dodger broadcaster who witnessed Hershiser break his mark with ten scoreless innings on September 28 at San Diego.

EJECTION. During the League Championship Series at New York's Shea Stadium, relief pitcher Jay Howell was ejected in the eighth inning of Game 3 after the Mets complained that Howell had pine tar on his glove. The Mets scored five runs that inning and beat Los Angeles, 8-4, to take a 2-1 lead in the series. Howell was suspended for two games of the National League Championship Series, eventually won by the Dodgers in seven games.

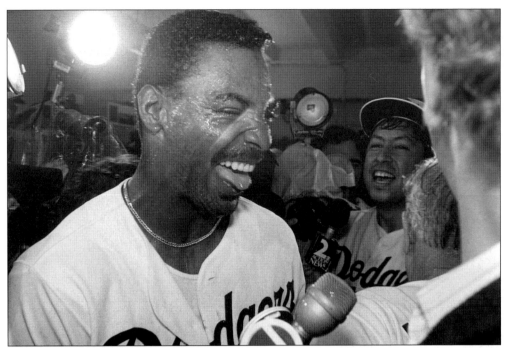

BALL FOUR. Mike Davis batted only .196 during the regular season in his first National League season in 1988. But the outfielder drew a two-out walk in the bottom of the ninth inning against Oakland Athletics relief pitcher Dennis Eckersley in the World Series opener at Dodger Stadium. The Dodgers trailed, 4-3, at that point and Davis' walk allowed Manager Tommy Lasorda to send pinch-hitter Kirk Gibson to the plate.

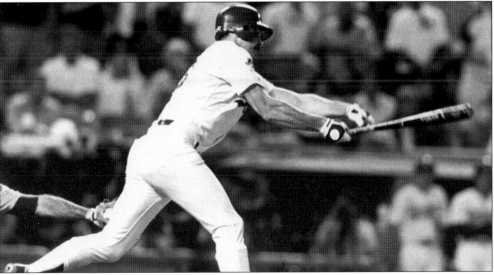

THE MIRACLE. Unable to play because of knee and hamstring injuries, Kirk Gibson appeared as a pinch-hitter in the 1988 World Series opener at Dodger Stadium. His game-winning home run off Dennis Eckersley with two out in the ninth inning gave Los Angeles a 5-4 victory. The National League's MVP hobbled around the bases and into World Series lore as the Dodgers eventually won the Fall Classic in five games.

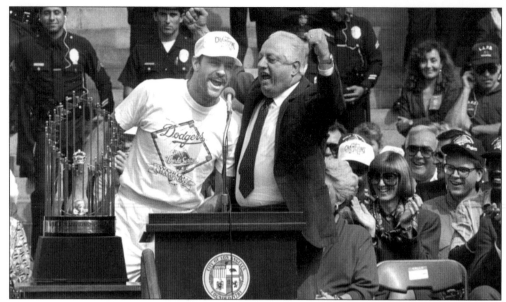

CITY HALL DANCING. Kirk Gibson and Tommy Lasorda celebrate the Dodgers' sixth World Championship on the steps of City Hall following their 1988 victory over the Oakland Athletics. Gibson's statistics were modest compared to other league leaders (.290 average, 25 home runs, 76 RBI), but his leadership and competitive nature garnered National League Most Valuable Player honors.

THE WHITE HOUSE. The World Champion Dodgers visited Washington, D.C. and President Ronald Reagan following their 1988 championship. Reagan returned to Los Angeles in 1991 and threw out the ceremonial first pitch on Opening Day at Dodger Stadium.

Six
The 1990s

The Dodgers celebrated their 100th season as members of the National League in 1990, but the party had barely begun when pitching ace Orel Hershiser was sidelined with a career-threatening injury to his shoulder. Doctors would perform surgery on his labrum, which eventually let "The Bulldog" resume pitching for another decade.

But Hershiser's spot in the rotation was hard to fill and a parade of candidates including Terry Wells, Mike Hartley, Dennis Cook, Tim Crews, Mike Maddux, Jim Neidlinger, and John Wetteland combined to make 35 starts. Fernando Valenzuela went 13-13 in his final season with the Dodgers, and Tim Belcher struggled at 9-9 after posting a promising 15-12 mark with 200 strikeouts in 1989.

The new ace of the pitching staff became Ramon Martinez, who at age 22 became the youngest Dodger to win 20 games since Brooklyn's Ralph Branca in 1947. Martinez also tied Sandy Koufax's team record with 18 strikeouts against the Atlanta Braves on June 4.

The Dodgers signed free-agent outfielder Darryl Strawberry prior to the 1991 season. Strawberry contributed 28 home runs, and veterans such as Eddie Murray and Brett Butler helped the Dodgers race to a 9^1/$_2$-game lead over third-place Atlanta at the All-Star break. But the Braves staged a comeback and outlasted the Dodgers by one game for the National League West title, which began Atlanta's string of postseason appearances that continued into the 21st century.

The heartbreak of losing a close race gave way to embarrassment in 1992 as the club staggered to a last-place finish and 63-99 record, the most Dodger losses in one season since 1908. Having pitched a combined 454 innings in his first two full seasons, Martinez slipped to an 8-11 record in 1992 and never again displayed his earlier dominance in a Dodger career that lasted until 1998. One of the few bright spots was first baseman Eric Karros, who was ticketed for Triple-A Albuquerque until an injury late in spring training to reliever Jay Howell opened a roster spot. Third on the first-base depth chart behind Todd Benzinger and Kal Daniels, Karros emerged the starter in late May and captured the first of the Dodgers' five consecutive Rookie of the Year honors.

Catcher Mike Piazza, though, was in a class of his own in 1993 as the first-year catcher shattered rookie records with a .318 batting average with 35 home runs and 112. RBI. He would

become one of the most prolific hitting catchers in baseball history, along with one of the most popular players in Los Angeles.

Next on the rookie parade was Raul Mondesi, who took over right-field duties in 1994 from Strawberry and displayed a powerful arm. The Dodgers were in first place at the time of another players' strike on August 12, but unlike 1981 and its happy ending in the World Series, the season was not resumed.

As the strike carried over into the spring of 1995, there wasn't immediate attention given to a Dodger pitcher who received a Triple-A contract, allowing him to attend spring training, while the 40-man rosters were frozen during the labor dispute. Hideo Nomo spent his first five seasons with the Kintetsu Buffaloes, but he wanted to pitch in the United States, something that hadn't been done by a Japanese pitcher in 30 years. The San Francisco Giants' Masanori Murakami had enjoyed success in 1964 and 1965, only to return to his country under extreme political pressure. Nomo felt the glare of the spotlight from the Japanese media, which chronicled his every move beginning in spring training. But the right-hander went 13-6 with a 2.54 ERA in 28 starts and his Rookie of the Year campaign opened the door for other Japan League stars.

Nomo's success helped the Dodgers reach the playoffs in consecutive seasons. But the Dodgers were swept in the Division Series in 1995 and by Cincinnati in 1996, which would leave Los Angeles 0-for-6 in playoff games during the decade. That period also marked the managerial transition from Tommy Lasorda to Bill Russell after Lasorda suffered a heart attack during the 1996 campaign. He opted for retirement and a club vice presidency instead of returning to the dugout in late July.

The rest of the decade featured more changes, as the O'Malley family ended its 48 years of ownership in 1998 and sold the franchise to The FOX Group. Russell would be followed by two other managers during the 1990s—Glenn Hoffman, hired by interim General Manager Lasorda in 1998, and Davey Johnson, hired during Kevin Malone's tenure as general manager.

The biggest player transaction after the O'Malley tenure occurred on May 15, 1998, when Piazza was traded along with third baseman Todd Zeile to the Florida Marlins in exchange for outfielder Gary Sheffield, infielder Bobby Bonilla, catcher Charles Johnson, outfielder Jim Eisenreich, and minor league pitcher Manuel Barrios. During the off season, they signed free-agent pitcher Kevin Brown to a seven-year, $105-million contract, making him the first major leaguer to break the $100-million plateau.

In January 1999, the Dodgers also announced a program of investment and limited renovation of Dodger Stadium, now the second-oldest facility in the National League behind Chicago's Wrigley Field, to make it more competitive with other ballparks across the nation. The Dodgers added new field-level seats down the foul lines beyond the dugouts, a new expanded dugout section with an adjacent club area, and suites were added on the Club Level. On April 20, 1999, the Dodgers surpassed the 100-million mark in home attendance since the stadium opened in 1962.

Following the 1999 season, former Warner Bros. Executive Bob Daly purchased a minority ownership stake in the Dodgers and became the club's chairman and managing partner. The team's final big trade of the decade occurred on November 8, 1999 when Mondesi was dealt to the Toronto Blue Jays in a four-player deal that brought outfielder Shawn Green to Los Angeles.

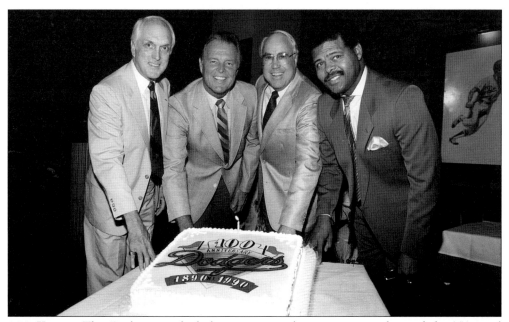

100 YEARS. The Dodgers marked their centennial season as members of the National League in 1990. From left to right, former Dodgers Carl Erskine, Don Drysdale, Duke Snider, and Reggie Smith pose in front of a special cake as an Oldtimers Day reunion highlighted a season-long celebration.

BACK TO EARTH. When Orel Hershiser walked off the mound on April 19, 1990, fans at Dodger Stadium didn't realize his career was in jeopardy. The next day, doctors discovered a torn labrum in Hershiser's right shoulder. It took a new surgical technique by team physician Dr. Frank Jobe, previously performed on professional golfer Jerry Pate, to save Hershiser's career. He returned to the majors in 1991.

NO-HITTER. In Fernando Valenzuela's final season with the Dodgers in 1990, he pitched his only career no-hitter on June 29 against the St. Louis Cardinals. The final batter he faced in a 6-0 victory at Dodger Stadium was former teammate Pedro Guerrero, who grounded into a double play started by second baseman Juan Samuel. Valenzuela won 141 career games with the Dodgers, which ranks fifth on the all-time L.A. list.

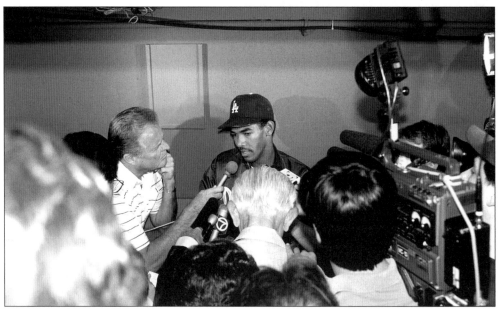

THE NEW ACE. With Orel Hershiser sidelined, Ramon Martinez became the new ace of the Dodgers in 1990. On June 4, he tied Sandy Koufax's team record with 18 strikeouts against the Atlanta Braves. Broadcaster Don Drysdale interviewed Martinez after the performance in which the last four Atlanta outs weren't strikeouts. Martinez posted a 20-6 mark in 1990.

EDDIE MURRAY. The future Hall of Famer played for the Dodgers from 1989 to 1991 after spending his first 12 seasons with the Baltimore Orioles. Murray batted .330 for Los Angeles in 1990. The first baseman also returned to the Dodgers in September 1997, capping a career in which he compiled 504 home runs and 3,026 hits.

GARY CARTER. The veteran catcher spent his only season with the Dodgers in 1991 as Los Angeles finished one game behind Atlanta in the National League West. Playing behind catcher Mike Scioscia, the 37-year-old Carter also served as a backup first baseman and batted .246 in 101 games.

GRAND PLANS. The Dodgers were optimistic at the start of the 1992 season with outfielders Darryl Strawberry, Brett Butler, and newcomer Eric Davis. But only Butler lived up to the expectations, batting .309 in 157 games. Strawberry and Davis were hampered by injuries and combined for 10 home runs as the Dodgers finished in last place with a 63-99 record.

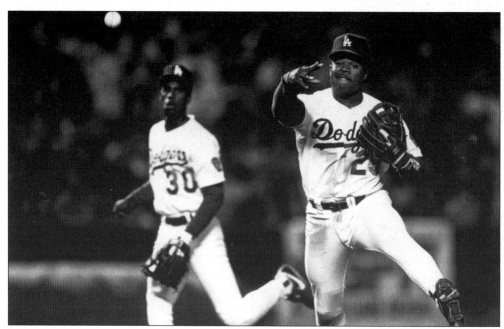

VERSATILE PLAYER. During the 1992 season, Lenny Harris started games for the Dodgers at second base, shortstop, third base, and the outfield. He batted .271 in 135 games with no home runs, 30 RBI, and 19 stolen bases. Harris later became a specialist coming off the bench, and in 2001 with the New York Mets he set a major league record for most career pinch hits.

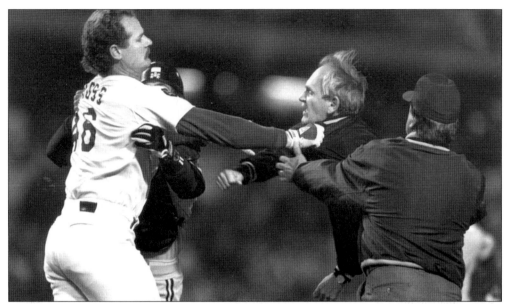

KEVIN GROSS. On August 24, 1993, the right-hander took exception to comments made by Pittsburgh manager Jim Leyland during a benches-clearing incident at Dodger Stadium. Gross won 40 games during his four-year tenure with the Dodgers, including a 12-1 victory over San Francisco on the final day of the 1993 season that knocked the Giants out of the playoffs.

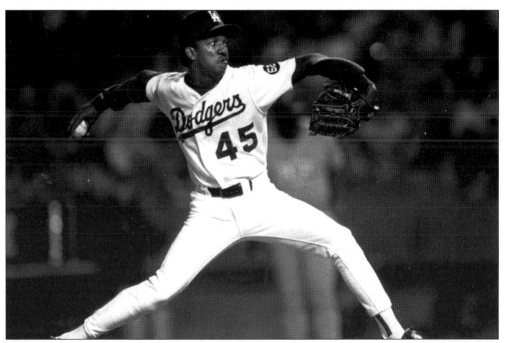

FUTURE STAR. Right-hander Pedro Martinez enjoyed his only full season with the Dodgers at age 21 in 1993. Primarily used as a middle reliever, Martinez went 10-5 with a 2.61 ERA in 65 appearances (two starts) with 119 strikeouts in 107 innings. When the Dodgers couldn't re-sign second baseman Jody Reed during the winter, they traded Martinez to the Montreal Expos for infielder Delino DeShields.

AMBASSADORS. Following the 1993 season, the Dodgers embarked on a Friendship Series tour to Japan and Taiwan. The exhibition tour was dedicated to the memory of Ike Ikuhara, a longtime assistant to Dodger president Peter O'Malley and a key player within the international baseball community. Ikuhara was named to the Japan Baseball Hall of Fame in 2002.

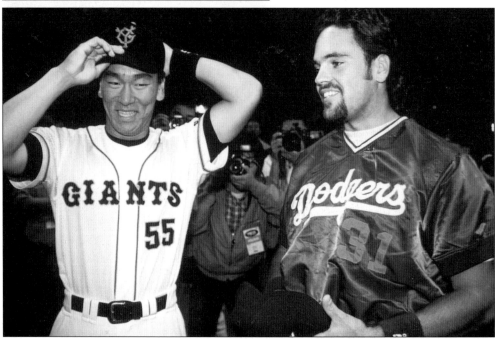

POWER BROKERS. During the Dodgers' 1993 Friendship Tour, Los Angeles catcher Mike Piazza met Tokyo Giants slugger Hideki Matsui, who eventually reached the United States as a member of the New York Yankees in 2003. Piazza rewrote the Dodger first-year record book during his Rookie of the Year campaign in 1993, batting .318 with 35 home runs and 112 RBI.

HIGH SELECTION.
With the No. 2 overall pick in the 1993 First-Year Player Draft, the Dodgers selected Wichita State pitcher Darren Dreifort, who won the Golden Spikes Award as baseball's top amateur player. In 1994, he and Chan Ho Park became the 17th and 18th players in major league history since the amateur draft began in 1965 to make their professional debuts in the majors.

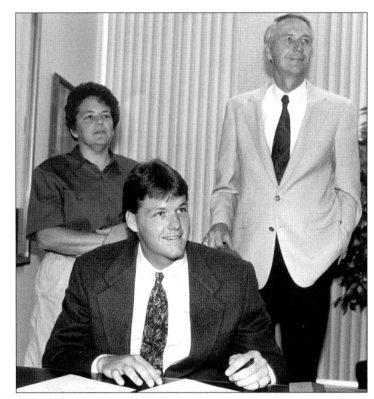

THE SCOUT. Mike Brito sits in the dugout with pitcher Ismael Valdes, who won 61 games in seven seasons with Los Angeles. In addition to signing Fernando Valenzuela and more than 20 others who reached the major leagues, Brito was a fixture behind home plate with his white Panama hat and radar gun.

103

BLACKBELT CLOSER. Relief pitcher Jim Gott led the Dodgers with 25 saves following Todd Worrell's injury in 1992. The Dodgers signed the nearby San Marino High School product as a free agent in 1990, two years after he registered a career-high 34 saves with the Pirates. The exuberant Gott, nicknamed "The Mayor" by Manager Tommy Lasorda, was also a third-degree black belt in the Korean martial art of Hapkido. He notched his first major league victory with Toronto against Baltimore on May 30, 1982, the day Orioles' shortstop Cal Ripken began his playing streak of 2,632 consecutive games.

HIDEO NOMO. When the right-hander signed with the Dodgers as a free agent on February 13 1995, he became the first Japanese-born player to join a major league team after playing professionally in Japan's Central or Pacific Leagues. The former Kintetsu Buffaloes star won National League Rookie of the Year honors with a 13-6 record and 2.54 ERA in 28 starts.

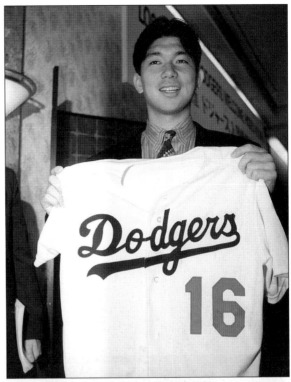

DIVISION CHAMPS. From left to right, pitcher Ramon Martinez, catcher Carlos Hernandez ,and pitcher Pedro Astacio celebrate the Dodgers' 1995 National League West title. The Dodgers edged Wild Card playoff entry Colorado by one game during the regular season but were swept in three games by Cincinnati in the Division Series.

CLOSER'S COMEBACK. After battling injuries early in his Dodger career, reliever Todd Worrell saved 111 games from 1995 to 1997, including a career-high 44 saves in 1996 as the Dodgers qualified for the playoffs as the Wild Card entry. Worrell retired after the 1997 season with 256 career saves with St. Louis and Los Angeles.

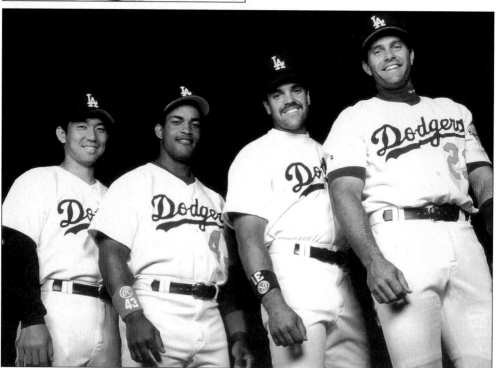

THE ROOKIE PARADE. From left to right, pitcher Hideo Nomo (1995), outfielder Raul Mondesi (1994), catcher Mike Piazza (1993), and first baseman Eric Karros (1992), gave the Dodgers four consecutive National League Rookies of the Year winners. In 1996, outfielder Todd Hollandsworth added his name to the first-year player honor roll.

SPECIAL CALL. During spring training in 1997, Tommy Lasorda received a phone call from the Veterans Committee, announcing the former Dodger manager's election to the Baseball Hall of Fame. Lasorda compiled a 1,599-1,439 record in a 20-year tenure that produced two World Series titles and four National League pennants.

SAFE AT HOME. Or at least at the Baseball Hall of Fame, where 1997 inductee Tommy Lasorda holds his plaque in Cooperstown, New York. It was a long way from Lasorda's early days in baseball, when he was bumped off the 1955 Brooklyn roster by rookie pitcher Sandy Koufax. After his pitching career, Lasorda served the Dodgers as a scout, minor league manager, and major league coach before replacing Hall of Fame manager Walter Alston on September 29, 1976.

JAIME JARRIN. The Dodgers' longtime Spanish-language broadcaster was named to the Hall of Fame in 1998 as recipient of the Ford C. Frick Award. Continuing a tradition of saluting its Hall of Famers, the Dodgers named a street sign in Jarrin's honor at their spring training headquarters as Manager Bill Russell offered his congratulations.

HONORING A PIONEER. On the 50th anniversary of his major league debut with the Brooklyn Dodgers in 1947, Major League Baseball saluted Jackie Robinson by announcing every team would permanently retire the Hall of Fame infielder's uniform No. 42. President Bill Clinton made an appearance at Shea Stadium, along with Jackie's widow, Rachel Robinson, during special ceremonies held in the fifth inning of the Dodgers-Mets game on April 15, 1997.

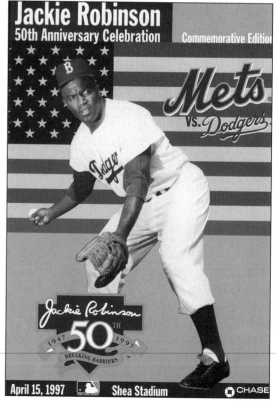

FOR SALE. Dodger president Peter O'Malley announced in 1997 that the ball club was for sale, ending 48 years of ownership by his family—the longest active tenure in the major leagues. On March 19, 1998, Major League Baseball owners approved the sale of the Dodgers for a reported $311 million to The FOX Group.

FATHER AND SON. Dodger pitcher Don Sutton and his son Daron had a chance to visit with Yankees' catcher Thurman Munson prior to a 1978 World Series game at Dodger Stadium, less than a year before Munson's tragic death in a plane crash. The Suttons were together again 20 years later when the 324-game winner was inducted into the Baseball Hall of Fame. Like his father, Daron Sutton became a major league broadcaster.

BIG NEWS. On May 15, 1998, the Dodgers sent All-Star catcher Mike Piazza and third baseman Todd Zeile to the Florida Marlins in exchange for outfielder Gary Sheffield, infielder Bobby Bonilla, catcher Charles Johnson, outfielder Jim Eisenreich, and minor league pitcher Manuel Barrios. Piazza, who was eligible for free agency following the 1998 season, embraces pitcher Ramon Martinez before leaving the Dodger clubhouse with the highest lifetime batting average (.331) in a Los Angeles uniform with a minimum 1,800 at-bats.

ROSTER SHUFFLE. As the team struggled with a 36-38 record on June 21, 1998, the Dodgers replaced Manager Bill Russell and General Manager Fred Claire. Former major league shortstop Glenn Hoffman, promoted from Triple-A Albuquerque by interim General Manager Tommy Lasorda, posted a 47-41 managerial record as the Dodgers finished in third place. Hoffman returned to the Los Angeles coaching staff in 1999 under new manager Davey Johnson and General Manager Kevin Malone.

GARY SHEFFIELD. Acquired in 1998 in a trade with the Florida Marlins, the All-Star outfielder became the first Dodger in Los Angeles history with at least a .300 batting average with 30 home runs, 100 RBI, 100 walks, and 100 runs scored in the same season. Sheffield accomplished the feat in 1999 and 2000. Overall, Sheffield hit 129 home runs with the Dodgers until his trade to the Braves following the 2001 campaign.

ON THE MARK. Despite missing 28 games in 1999 due to a broken hand, Mark Grudzielanek batted .326, the highest average by a National League shortstop since Pittsburgh's Arky Vaughan batted .335 in 1936. Grudzielanek also became the fifth Dodger shortstop to hit at least .300 in a season (minimum 100 games), joining Brooklyn's Tom Corcoran (.300 in 1893), Glenn Wright (.321 in 1930), Pee Wee Reese (.309 in 1954), and Los Angeles' Maury Wills (.302 in 1963).

SEVEN
2000 and Beyond

A new decade brought a different look to the Dodger offense as Los Angeles set a single-season record with 211 home runs. Gary Sheffield tied Duke Snider's franchise record with 43 home runs, Eric Karros surpassed Ron Cey's career Los Angeles record of 228 home runs, and Dave Hansen came off the bench with a record seven home runs as a pinch hitter.

But along with the new-look Dodgers, the Arizona Diamondbacks joined the National League West as an expansion team in 1998 and won a division title in only their second year of existence. By 2001, the Diamondbacks were World Champions. The Giants also provided tough competition as outfielder Barry Bonds won three consecutive league MVP awards from 2001 to 2003. The Dodgers won 93 games in 2002 under Manager Jim Tracy, but it was still only good enough for third place behind San Francisco and Arizona.

Prior to the 2002 season, the Dodgers attempted to sign free-agent closer Jeff Shaw, who saved a franchise-record 129 games with Los Angeles from 1998 to 2001. But Shaw insisted he wanted to retire and spend time with his family. Indeed, this wasn't a negotiation ploy and the Dodgers went to spring training camp without a closer. They toyed with the idea of effective middle reliever Matt Herges but were more intrigued by Gagne, the hard-throwing prospect who couldn't put things together as a starter. General Manager Dan Evans traded Herges to the Expos for pitcher Guillermo Mota. An original closer-by-committee plan that included left-hander Jesse Orosco was soon scrapped with Gagne's first save during challenging circumstances on the road in San Francisco. Gagne rewarded the Dodgers' gamble with 52 saves in 56 opportunities in 2002. Just as the "Dodger Blue" sentiment blossomed in Lasorda's first year as Dodger manager, so did the popular "Game Over" slogan originally coined by teammates explaining their confidence in Gagne when he entered the ninth inning and the Dodgers were leading.

In 2003, Gagne enjoyed a "perfect" season and converted all 55 save opportunities and became the sixth Dodger pitcher to win Cy Young Award honors, joining Don Newcombe (1956), Don Drysdale (1962), Sandy Koufax (1963, 1965, 1966), Mike Marshall (1974), Fernando Valenzuela (1981), and Orel Hershiser (1988).

The Dodgers celebrated their 40th anniversary in Los Angeles in 2002. Former Dodger president Peter O'Malley threw out the ceremonial first pitch on Opening Day as his sister,

Terry Seidler, watched with pride. It was an honor performed by their mother, Kay O'Malley, prior to the first game in Dodger Stadium history on April 10, 1962. Along with Peter O'Malley were other longtime stadium employees, including Roger Owens, the loge level "Peanut Man" whose enthusiasm and creative pitching deliveries made him the most famous food vendor in professional sports. Other honorees included Rosalind Wyman, the former Los Angeles City councilwoman who, along with Mayor Norris Poulson and County Supervisor Kenneth Hahn, played a significant role in the Dodgers' move from Brooklyn in 1958.

And four decades on the West Coast gave the Dodgers memories and standout performers to place alongside those from Brooklyn. Along the pavilion roofs at Dodger Stadium are the names of the 10 retired jerseys belonging to Pee Wee Reese (1), Tommy Lasorda (2), Duke Snider (4), Jim Gilliam (19), Don Sutton (20), Walter Alston (24), Sandy Koufax (32), Roy Campanella (39), Jackie Robinson (42), and Don Drysdale (53).

Other familiar faces remained fixtures at the ballpark while some, such as former 1981 World Champion Dodger teammates Rick Monday and Fernando Valenzuela, became broadcasters. Valenzuela returned to the booth in 2003 and was reunited with Hall of Famer Jaime Jarrin, the longtime Spanish voice of the Dodgers who served as the pitcher's interpreter during his rookie campaign. Lasorda even temporarily left his post as a Dodger vice president in the summer of 2000 and accepted a challenge as the United States Olympic baseball coach. His squad returned from Australia with the gold medal after defeating Cuba in the championship game.

No matter how many things changed with the Dodgers in Los Angeles, one golden aspect endured through the generations—Vin Scully. The Hall of Fame announcer was hired by Brooklyn Dodger president Branch Rickey in 1950 and his first manager was Burt Shotton, who opted to wear civilian clothes and a Dodger warm-up jacket instead of a traditional uniform. Brooklyn broadcasting icon Red Barber served as a mentor to the Fordham University product and preached to Scully to bring his own qualities into the booth and not copy the style of other broadcasters.

"I was aware after the first few times I heard my voice that I was better if I saw things with my eyes and not with my heart," Scully said. "I didn't want to allow emotion to color my broadcasting and the way I would weigh facts. The first thing I had to do was say to myself, 'You're not a fan. You can't stand up and scream and holler because you don't sound good when you do that. You're going to have to maintain a tremendous amount of personal discipline.' I think that's the first serious lesson I learned about myself when I was on the air."

In 1976 the Dodgers conducted a vote among their fans, asking them to name "The Most Memorable Personality" in Los Angeles history, Scully won by a landslide. In July 2000, Scully was elected sportscaster of the 20th century by a vote of the American Sportscasters Association. And who else could relate a story about 20-year-old Edwin Jackson in 2003 and the previous Dodger pitching debuts of players such as left-hander Karl Spooner, who fanned 15 batters in his first game with Brooklyn in 1954.

"Vin Scully taught people about baseball in Los Angeles," former Dodger General Manager Buzzie Bavasi said. "Even those who didn't know about the sport liked to hear him on the radio. He was the most important person in making the Dodgers as popular as they are today."

GREEN ACRES. The Dodgers acquired outfielder Shawn Green in a four-player trade with the Toronto Blue Jays on November 8, 1999. Green hit 115 home runs in his first three seasons with the Dodgers, including a franchise-high 49 in 2001. He also set a record with seven home runs in three consecutive games from May 23 to May 25, 2002.

TEDDY BALLGAME. Hall of Famer Ted Williams made his final visit to Dodgertown during spring training in 2000. From left to right are former major league pitcher Eldon Auker, Williams, Dodger vice president Tommy Lasorda, and Dodger chairman Bob Daly.

SURPRISE REUNION. Nobody could have predicted this picture when St. Louis Cardinals' slugger Jack Clark knocked Tommy Lasorda and the Dodgers out of the 1985 playoffs with a ninth-inning home run off reliever Tom Niedenfuer at Dodger Stadium in the League Championship Series. But Clark served as Dodger batting coach from 2001 to 2003, joining Sal Maglie, Juan Marichal, and other former nemesis who eventually wore a Dodger uniform.

STARTING OVER. When Eric Gagne made five starts after his September 1999 promotion from Double-A San Antonio, it appeared the right-hander would become a member of the rotation. But Gagne posted an overall 10-13 record and 4.68 ERA as a starter and he struggled to find his consistency in 2000 and 2001, leaving his future role with the Dodgers in doubt.

JESSE OROSCO. In his first tenure with the Dodgers, reliever Jesse Orosco was a member of the 1988 World Championship team and perhaps best remembered for a spring training prank that backfired against Kirk Gibson. The left-hander returned more than a decade later and pitched with Los Angeles in 2001–2002. At age 46, Orosco was still in the majors in 2003 and extending his all-time record for most appearances.

PARK PLACE. Right-hander Chan Ho Park became the first player from Korea to play in the majors. During his career with the Dodgers from 1994 to 2001, Park posted an 80-54 record and 3.80 ERA in 221 games. He won a career-high 18 games with Los Angeles in 2000.

PINCH OF POWER. Dave Hansen set a major league record with seven home runs as a pinch-hitter in 2000. The Southern California native broke into the big leagues with Los Angeles at age 21 in 1990, and he established the Dodger career record for most pinch hits with 109, surpassing the previous mark of 106 set by Manny Mota.

JEFF SHAW. During his four seasons with the Dodgers, the right-hander compiled a Los Angeles record for most career saves, surpassing Todd Worrell (127) and Jim Brewer (125). He was traded to the Dodgers prior to the 1998 All-Star break and became the first player in history to lead two different teams in saves—23 with Cincinnati and 25 with Los Angeles.

MEDICAL PIONEER. Dodger team physician Dr. Frank Jobe has extended the careers of numerous pitchers thanks to his revolutionary elbow ligament and tendon transplant surgery, first performed on Dodger pitcher Tommy John in 1974. Jobe displays a plaster model of his hand holding a scalpel, a gift from Los Angeles pitcher Darren Dreifort.

SIX-SHOOTER. During his breakout season in 2001, catcher Paul Lo Duca enjoyed a 6-for-6 afternoon during the Dodgers' 11-10 victory in 11 innings at home over the Colorado Rockies on May 28. Lo Duca became the first Dodger since Willie Davis in 1973 with six hits in one game and the first catcher in the majors to accomplish the feat since Walker Cooper of the 1949 New York Giants.

ROD DEDEAUX. The former University of Southern California baseball coach won 11 NCAA titles during his collegiate career. A former shortstop on the 1935 Brooklyn Dodgers, Dedeaux served as an international baseball ambassador and became the first United States Olympic Baseball coach in 1984, one of many honors in a celebrated career. He received a bat from Hall of Famer Babe Ruth for winning the city batting championship at Hollywood High in Los Angeles, hired a batboy named George "Sparky" Anderson for his 1948 national championship team at USC, and later coached Randy Johnson, Tom Seaver, and Mark McGwire. He coached against Los Angeles managers Walter Alston and Tommy Lasorda for two decades during the annual USC-Dodgers public workout in February.

KAZUHISA ISHII. After signing with Los Angeles as a free agent in 2002, the former Yakult Swallows standout in Japan's Central League won 14 games in his first season with the Dodgers, the most by a Dodger rookie left-hander since Brooklyn's Joe Hatten won 14 in 1946. Ishii's season was cut short on September 8 when he was struck by a ball off the bat of Houston's Brian Hunter on the left side of his forehead, causing a nasal fracture.

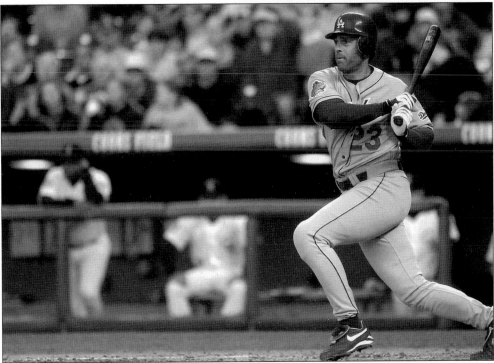

ERIC KARROS. The UCLA graduate became the all-time Los Angeles career home run leader with 270 during his tenure with the Dodgers from 1991 to 2002. Karros surpassed the previous home run record of 228, set by third baseman Ron Cey from 1971 to 1982. Karros also ranks second on the L.A. career list with 582 extra-base hits and 976 RBI.

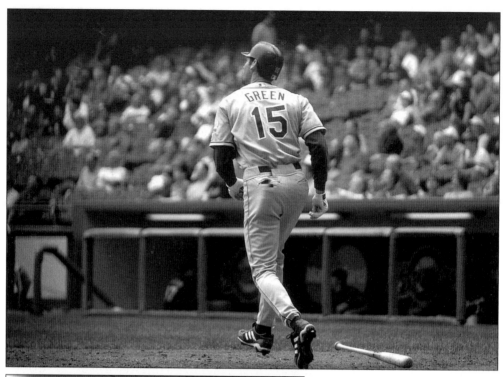

ONE FOR THE BOOKS. Outfielder Shawn Green watches the last of his four home runs clear the fence at Milwaukee on May 23, 2002 during a 16-3 victory over the Brewers. Green went 6-for-6 with a double, single, six runs scored, and seven RBI, and he set a major league record with 19 total bases. In the clubhouse, Green celebrated his feat with teammate Omar Daal.

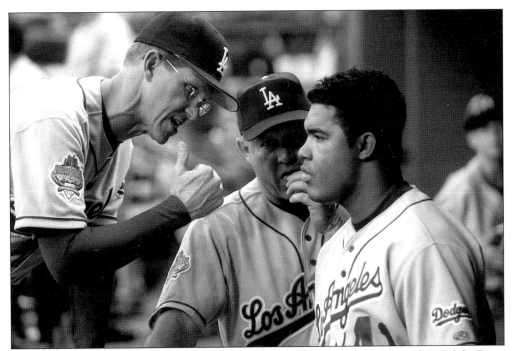

BATTLE PLAN. Manager Jim Tracy discusses strategy in the dugout with pitcher Odalis Perez as Coach Jim Colborn looks on during a game in 2002. In his first season with Los Angeles, the left-hander went 15-10 with a 3.00 ERA and was named to the National League All-Star team. He also joined Orel Hershiser (1985) as the only Los Angeles pitchers with two one-hitters in the same season.

JOHN SHELBY. The Dodger first base coach shares a moment in the dugout with his son Jeremy during the 2002 season. The former center fielder won World Series titles with Baltimore in 1983 and Los Angeles in 1988. He joined the Dodger coaching staff in 1998.

GLOBAL GAME. In 2002, outfielder Chin-Feng Chen became the first Taiwanese-born player to appear in the major leagues when he was recalled from Triple-A Las Vegas on September 9. Chen later appeared at a press conference at Dodger Stadium and answered questions about his international career, which included playing in the 1990 Little League World Series in Williamsport, Pennsylvania, as Taiwan won the championship game.

KEVIN BROWN. After injuries limited him to just 17 appearances in 2002, the right-hander regained his All-Star status in 2003 and won nine consecutive decisions in the first half of the season. Brown finished with a 14-9 mark and his 2.39 ERA ranked second in the National League.

DODGER DRAFT CHOICES. Xavier Paul, left, from Slidell High School in Louisiana, was a fourth-round selection of the Dodgers in the 2003 First-Year Player Draft. During his first visit to Dodger Stadium, the outfielder met bench coach Jim Riggleman, who was tabbed by Los Angeles in the fourth round of the 1974 draft after his career as an infielder and outfielder at Frostburg State College in Maryland.

MEMORABLE DEBUT. Following a promotion from Double-A Jacksonville, rookie Edwin Jackson made his major league debut on his 20th birthday on September 9, 2003. Jackson defeated Randy Johnson and the Arizona Diamondbacks, 4-1, at Bank One Ballpark. The right-hander scattered one run on four hits in six innings in becoming the third-youngest Los Angeles pitcher to start a game and the youngest to win his first start.

PAUL LO DUCA. The catcher earned All-Star honors for the first time in his career in 2003. Lo Duca batted .314 in the first half, including a 25-game hitting streak, the second longest in Los Angeles history. Lo Duca and reliever Eric Gagne participated in a Major League All-Star Tour of Japan following the 2002 season.

NOMO MILESTONE. Right-hander Hideo Nomo notched his 100th career victory in the major leagues against the Giants on April 20, 2003. After spending his first five seasons with the Kintetsu Buffaloes in Japan, Nomo made his Dodger debut on May 2, 1995 at San Francisco's Candlestick Park. Nomo would become only one of four pitchers to hurl a no-hitter in both the American and National Leagues, joining Jim Bunning, Nolan Ryan, and Cy Young.

GAME OVER. Right-hander Eric Gagne enjoyed a "perfect" season in 2003, converting all 55 save opportunities en route to the National League Cy Young Award. Gagne also set a major league mark with 63 consecutive saves, dating back to August 28, 2002. The Dodgers converted Gagne into a closer during spring training in 2002, and he responded with 52-for-56 in save situations. Gagne was the quickest reliever to reach 100 career saves and the only one to post consecutive 50-save seasons. Other Dodger Cy Young Award recipients include Don Newcombe (1956), Don Drysdale (1962), Sandy Koufax (1963-65-66), Mike Marshall (1974), and Orel Hershiser (1988).

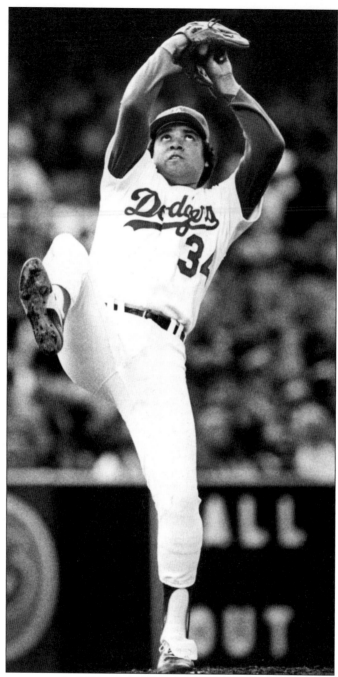

FERNANDO VALENZUELA. In 1981, the left-hander from Mexico became the first major leaguer to win both the Rookie of the Year and Cy Young Awards in the same season. It all began when Valenzuela was tapped as an emergency starter on Opening Day because of injuries to Jerry Reuss and Burt Hooton. In his first major league start, the 20-year-old pitched a 2-0 complete game against the Houston Astros at Dodger Stadium. With five shutouts in his first eight starts, an 8-0 record, and 0.50 ERA, "Fernandomania" emerged as one of the most memorable chapters in Los Angeles history.